Ceramics

RotoVision

For my grandparents Sotira and Lefteri Stasi.

Ceramics

Materials for Inspirational Design

Chris Lefteri

A RotoVision Book
Published and distributed by RotoVision SA
Route Suisse 9
CH-1295 Mies
Switzerland

RotoVision SA, Sales & Production Office
Sheridan House, 112/116A Western Road
Hove BN3 1DD, UK

Tel: +44 (0)1273 72 72 68
Fax: +44 (0)1273 72 72 69
E-mail: sales@rotovision.com
www.rotovision.com

10 9 8 7 6 5 4 3 2 1

ISBN 2-88046-668-7

Edited by Leonie Taylor
Series Editor Zara Emerson
Book design by Lucie Penn
Cover design by Frost Design
Photography by Xavier Young

Production and separations by
ProVision Pte. Ltd. in Singapore
Tel: +656 334 7720
Fax: +656 334 7721

Printed and bound in China by Midas Printing

Contents

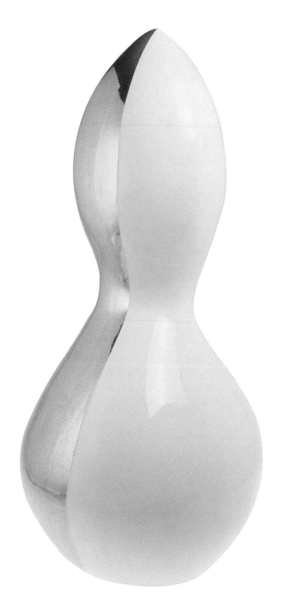

My first recollection of ceramics as a child is in Cairo, when I was just two, seeing my father's expressive sculptures and vases, with stylised painted faces and imagery; with carafes as birds, bowls of human figures, angels or animals, and their organic, colourfully glazed abstract forms. It felt like a natural extension of the earth, of nature and man, of ideas manifested into hard, shiny, pure, fundamental artistic expressions. I saw sand transformed into things so beautiful and so human. I liked the hollowness of the objects, the holes, the negative and positive, the scale, their preciousness and precariousness, their fragility, their shine and their matt.

In high school, I remember throwing clay on a wheel in search of symmetry and perfection. Later, as I started practicing the overtly pragmatic profession of industrial design, I rarely had a chance to design with this ancient, primitive material. I always wanted to touch, play and manipulate the earthy clay, but I spent 20 years doing industrial products with plastics and other 20th century materials, so rarely touching ceramics. For some reason it seemed to me like a material of the artisan, not the designer. I loved ceramic, but had very little opportunity to work it. In a way, I always saw it as a poor man's material, as a means of craft or sculpture, being naive of the potential of its limitless boundaries. My favourite porcelain tended to be tabletop items by Eva Zeisel, Stig Lindberg, Russell Wright, Raymond Lowey, and I always liked the more sculptural narrative objects by Ettore Sottsass. In North America, industrial design has been quite specialised, so if one did high-tech products, they worked on the opposite spectrum of the ceramic typology. Ceramics were more artistic, less functional objects, more feminine, that stayed in the hands of more 'sculpture' types or with 'tabletop'

designers, than with someone designing laptops, snow shovels or medical equipment as I was.

What I loved about ceramics from afar was the organic liquid solid that is fired to become so hard yet fragile. This juxtaposition is beautiful, because the end result speaks about its organic liquid nature. In high-volume ceramic production for a great part of the early 20th century, tabletop ceramics were always symmetrical and round, based on tooling methods and 'spinning' the clay. But the projects that I always recollect are all these methods of keeping ceramics inexpensive in production but finding simple ways of distorting or morphing the forms. Pinching, twisting, cutting, and other hand methods, much like glass, were employed in the 1930s and became common in the 1950s, to create the more organic artistic forms of my favourite 'organic period'. Tapio Wirklal made some very sophisticated work for production, and ceramics and porcelain pieces of this time were items I was exposed to in my childhood. Noguchi, Dali, Eames, and so many artists all experimented with ceramics, an omnipresent material at this time for cultural expression. But then it seemed like ceramics (at least in the housewares and gift sector) did not really progress in ideology. They lost their trend and market, and banal products such as plates and mugs just became typical volume goods and part of our dismal mass-production landscape. In 1981, the Memphis group surprised the world with all these pop objects that included a large range of ceramics comprised of vases, bowls, ambiguous containers by Thun, Cibic, Pasqueir, Zanuso, Peter Shire, and of course the poet of ceramic sculpture, Sottsass. It seemed like a perfect, inexpensive, playful expressive 'design' material that had a rebirth in the 1980s. It was cheap, available, accessible, and one could create ceramics with inexpensive tooling for

Foreword

small batch productions. Glazes, finishes, variations in clay, variable firing techniques, etc. opened up great artistic freedom for production objects. All of a sudden, every designer was creating ceramic products, which became more acceptable in the designer's portfolio. Large companies, from Rosenthal to Mikasa, created more expressive, funkier things. The bathroom industry is now in full expressive force with a plethora of form variations. Production costs are low, formal expression is high.

But I haven't even touched on the fact that ceramic is also a brilliant material that seems split between technological, functional applications and the decorative expressions I have spoken about. I remember about 10 years ago in Gifu prefecture in Japan seeing a ceramic knife for the first time — it seemed like the most elegant feat of technology, yet it had the innocence and purity of a very simple primitive material. The beauty of clay is that this indigenous natural material is so flexible, so transformable, mutable, utile with infinite technological possibilities. Unlike plastics, you can have variable wall thickness, undercuts, from thin to thick, from bohemian to modern, from minimal and delicate to excessive.

A brilliant material from technological and environmental, to high performance, to even hybrids such as cermets and smart applications. New applications are constantly being found for advanced ceramics, which are becoming cheaper and more available all the time. From salt and pepper shakers to superconductors, ceramics are our ancient and possibly our future material world.

Materials have always inspired designers, and interestingly, Material development and material engineering seem to exist without application. Design, in its larger construct — the plan and development of a service, good, or material — must find new applications for these novel materials, apply them to beautify our world, to socialise the material, to shape a physical utopia for a more poetic and seamless way of life.

I love materials. I love the feeling, of physically touching, of seeing, of smelling, of tasting a material world, where I feel alive and free. When one touches a beautiful, eloquent thing, physical material becomes metaphysical and our minds ascend to the sixth dimension.

Karim Rashid

Ceramic springs, building bricks, talc, graphite, concrete, porcelain, ceramic fibres and papers, chalk, silicon carbides, oxides, glass and terracotta are all part of the ceramics family. With so many varieties and applications, ceramics is difficult to define. It encompasses a multitude of product areas that range from building materials to teacups, bulletproof vests to kitchen knives. Some definitions describe ceramics simply as 'fired clay' but this doesn't allow for the advanced materials like nitrides, borides and carbides, or even glass. We could have the technical description that talks about 'one-phase' and 'multi-phase', but who really understands that stuff? A good definition should sum up the character of this slippery substance. One of the most straightforward and assessable ways to sum up a material is by the key physical and mechanical properties that distinguish them from each other. So here it is: ceramics are hard, they have excellent compression strength, high melting points and a good resistance to chemicals. It is these properties, coupled with, in some of the more traditional cases, the cost, manufacturing potential and versatility, that gives ceramics an unrivalled advantage in so many industries.

Ceramic is a wonderful material; malleable and pliable, it can be pushed and pulled, squeezed and moulded, poured and ground. It can be immediate and simple to form, but at the same time it can be highly precise and shockingly hard, with the most enduring of physical properties. Yes, it can be played with in the school art room but it is also used in incredibly advanced applications and applied in extreme environments like the Space Shuttle tiles. It can be polished to an extraordinarily smooth surface but it is also appreciated for its surface texture. It is this diversity and versatility which makes ceramic difficult to characterise.

It is also hard to classify ceramics by putting them into product areas, because the applications are so varied. Unsurprisingly, most people immediately imagine mugs, plates, bowls and cups when they think of ceramics. It seems to be the best hard-wearing, long-lasting and hygienic material for dinnerware, with no other materials in line to take its place. These products of function and adornment also take advantage the unique ability of ceramics to form an alliance with a painted, glassy skin, creating a decorative and hard surface. It is this attribute that allows the same product to be sold with several different surfaces. A particular dinner service by Royal Doulton, for example, can be reproduced in many ranges requiring only a change in the surface patterns. These humble products represent an everyday application for ceramic, but one that can also be beautiful and ornamental and personal.

To define ceramics by production or variety is also difficult. Like many materials, ceramic is regional. Sure, you can ship clay anywhere in the world, but there are many regions that use local quarried clay to produce distinctive clay bodies. It is also like wood in the sense that local industries and towns are built around where it is found. Anyone, in almost any part of the world, can make a ceramic product with the biggest investment being an oven to fire it. As a result, it can be highly versatile in terms of production from small-scale low volumes to high production runs.

As other materials in this series of books have proved, it is the less visible products and applications that are hidden in the vast depths of industry that provide some of the most interesting and surprising profiles: ceramic springs used where tension is needed in extremely high temperatures; microscopic, hollow spheres blended with paint to provide thermal insulation; or ceramic papers used for their flame-stopping properties as safety features on aircraft. This is a book about production and design on a commercial level. Instead of merely showcasing work from craftsmen and ceramicists, this book discusses ceramics as applied to mass and batch production, its materials and uses. It contains applications of ceramics in their cultural context and examples of their use in a more technical and industrial context. This book offers more stimulating suggestions with examples of where these boundaries have been crossed.

Preface

How to use this book

This book continues the Materials series by offering the inquisitive reader a rich and unique introduction to ceramics. The chapters fall into two main sections. The first section features a range of projects, products and processes which look at a sample of ceramics in various forms, featuring some everyday products and some which have never been published before. Each page features a different product. The information for each feature is divided into three layers of information, containing the basics. The text is deliberately easy to digest. For those who want more in-depth technical knowledge, each page contains details of where to find more information, usually supplied as a website. The 'where' part of each page also gives details for further information. These details may not necessarily be the producers of the product described, but provide an avenue for further information. Although the contact details are given on each page, this is only a guide. In most cases they are by no means the only suppliers of the material. A reference guide is also included on each page for cross-reference to subjects on other pages. The key features on each page break down the material or process into its basic properties. If pages do not have key features it is because they are not relevant to that inclusion. 'Typical applications' contextualises the material by suggesting other areas where the material or process is used.

The second section of the book is a reference guide to the main ceramic materials in general use. This guide gives specific information on types of ceramics and production methods. There is also a list of Weblinks to key ceramic producers, associations, suppliers and material suppliers.

As with other books in this series, the purpose is to offer a taste of some of the most interesting materials out there and list where to get hold of them, so please browse, enjoy and tuck in to some of the most inspiring offerings from the ceramic material world.

013 Advanced ceramics

014

Energy transfer

Ceramics are generally hard, dense, stiff and strong, but not very flexible. So when you shoot a bullet towards a ceramic breastplate, it will shatter as you would expect of a ceramic, thus absorbing the impact of the bullet. Without getting too technical, the whole principle relies on transferring energy. The energy of a bullet travelling at a high velocity is transferred to the shattering of a ceramic plate.

Ceramics are great at compression ⍀ but not so good when in tension: look at brick walls still standing after thousands of years. The purpose of the ceramic body armour is to absorb the energy of the bullet. As the bullet hits the vest it will try to bend it, but as ceramic is not very good at bending the back part, the plate will shatter, supported by a Kevlar® mesh which is extremely good in tension.

These vests made from compression-moulded alumina ⍀ are formed into a range of single or compound curved tiles, depending on where they go on the body. Alumina is one of the most commonly used materials in the ceramic industries and is available in a range of purities to suit different applications.

Dimensions	24cm x 29cm x 5mm
Key Features	**Widely available**
	Good strength and stiffness
	Good hardness and wear resistance
	Can be processed using a large variety of processing methods
	Good corrosion resistance
	Good thermal stability
	Machinable
	Excellent electrical insulation
	Can be readily joined to metals
More	**www.morganadvancedceramics.com**
Typical Applications	**Alumina is one of the most popular advanced ceramic materials. Its good wear resistance makes it ideal for parts such as textile guides, dies, bearings, electrical insulator on spark plugs and medical prostheses. Its wide availability and range of properties also makes it suitable for electronic substrates and for making ceramic fibres and papers**

Body armour
Manufacturer:
Morgan Advanced Ceramics

016

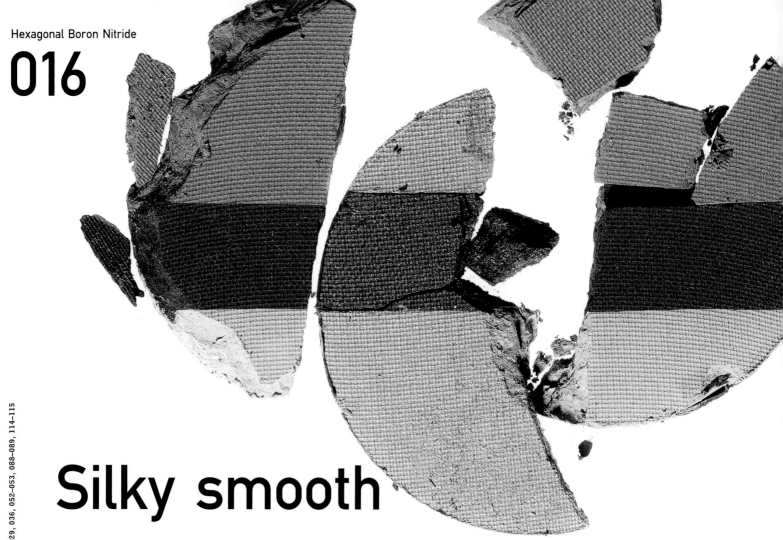

Silky smooth

Want to leave your skin feeling silky smooth? Then why not try some boron nitride ↘ in your make-up? Although used in small quantities, typcially between three and ten per cent is added to cosmetics. This ingredient offers a soft, elegant feel with good skin adhesion, while providing various optical features.

But this is a material that, in different grades, offers a range of contradictory applications. Together with diamond and silicon nitride ↘, cubic boron nitride is one of the hardest materials around and is superb for cutting tools.

There are two types of this material: hexagonal boron nitride, which has high temperature applications similar to graphite and is known for its soft and lubricious qualities; in contrast, cubic boron nitride is reknowned for its hardness and its use for cutting, grinding and drilling.

Key Features	**Silky feel**
	Excellent adhesion
	Can be tailored and applied to a range of products
	Has a non-transfer property
	Good lubrication
	Chemically inert
	Non-toxic
More	**www.debid.co.uk**
	www.bn.saint-gobain.com
	www.acccos.com/
Typical Applications	**High-purity powders are used in cosmetics like foundations, lipsticks, pencils, etc. Its good lubrication qualities make it useful for minimising friction in a variety of materials and industrial production methods**

**Cosmetics with particles of
hexagonal boron nitride
Manufacturer: St Gobain**

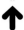

Tough

Zirconia ⬎ is another commonly used high-performance ceramic. Used over alumina because it is tougher and will resist cracking more easily, its particles are small, which gives it a sleek surface finish suitable for products such as blades ⬎, pistons, bearings ⬎ and even luxury jewellery.

Most watchmakers use more conventional materials for their timepieces — steel, plastic, brass, gold — but not Rado. Since the Rado brand was first used in 1957, the Swiss watchmaker has built a reputation for its unique application of advanced materials.

In a short period of time, Rado established the world's first scratchproof watch, their aim being, 'To make watches that are beautiful and stay beautiful'. It was in the 1980s that ceramics were first used as part of their assortment of high-performance materials. By this time, ceramics had already proved themselves in a range of technical applications like the space shuttle ⬎. This offered Rado the possibility to produce an extremely hard, scratch-resistant material that would live up to their aim.

Ultra-fine zirconium oxide or titanium-carbide powder is used for the ceramic watches. These powders are pressed into shape and sintered at a temperature of 1,450°C. The components are then polished with diamond dust to achieve the ultra-shiny, metallic surface. The company also use ceramic injection moulding for the Ceramica range, which allows for the production of intricate, complex forms. The colours are achieved by using ultra-pure, high-melting-point colour oxides that are mixed with the ceramic powder to enable colour variations.

**Sintra Chronograph
ceramic watch
Manufacturer: Rado
Launched: 1993**

Dimensions	Watch face 3.45cm x 3.2cm
Key Features	**Excellent strength and fracture toughness**
	Very hard and wear resistant
	Good chemical resistance
	High temperature capability up to 2400°C
	Dense
	Low thermal conductivity (20% that of alumina)
More	**www.rado.com**
Typical Applications	**As well as being used in these watches, its smooth and fine surface finish combined with its toughness makes Zirconia an ideal ceramic for cutting blades and kitchen knives (see page 18). It is also used in car oxygen sensors which use a form of electrically conductive zirconia. Other applications include medical prostheses and pump seals and valves**

more: Zirconia 018–019, 037, 052–053, 118–119 Blades 018–019 Bearings 028 Space Shuttle 020, 036

018

Harder than stee

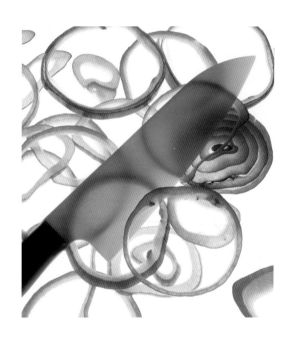

Dimensions	**7.5cm–15.3cm blade**
Key Features	**Lighter than steel**
	50% harder than steel
	Chemically inert
	Good stiffness
	Blade can be formed in a variety of production processes
More	**www.kyocera.de**
	www.kyoceraTycom.com
	www.kyocera.co.jp
	www.sorma.net
Typical Applications	**Zirconia and alumina are popular materials among the advanced ceramics group. They are used for a wide variety of products, with a large number of industrial applications. These include electrical insulators, ballistic armour, medical prostheses, tool dyes for industrial production and grinding media**

The process of making ceramic knives involves a number of separate stages. First the shape of the blade or blanks is formed by pressing ⬎ ceramic powder with special binders. These binders help to hold the shape. These are then fired at over 1000°C. The blank at this stage does not have a sharp edge – this is ground on during a separate process using a diamond wheel. A handle can then be attached.

Both black and white blades are made from an advanced ceramic called zirconium oxide ⬎. At room temperature, zirconia is one of the strongest and toughest materials around. Although it is similar to alumina ⬎, it is tougher and has a much greater resistance to wearing. The sleek surface is achieved through the small size of the grains. This makes it an ideal material for blades.

Although both colours are made from zirconia, the black blades are treated for extra durability. This is achieved by subjecting the blade to an extra firing process.

The nature of ceramics means they are more brittle than metal. So if you are carving into bone, or use the knife as lever, this may damage the edge.

Kyocera ceramic kitchen knives
Signature series
Manufacturer: Kyocera

more: **Pressing** 030–031, 086–087, 116 **Zirconia** 017, 037, 052–053, 118–119 **Alumina** 014–015, 029, 036, 048–049, 052–053, 070–071, 082–083–098–099, 118–119 **Blades** 017 **Metal Replacement** 021, 029, 036, 052–053 **Piezoelectric** 024–025 **Machining** 022, 030 **Chemical Inertness** 016, 029, 036, 052–053, 088–089

020

Heat beating

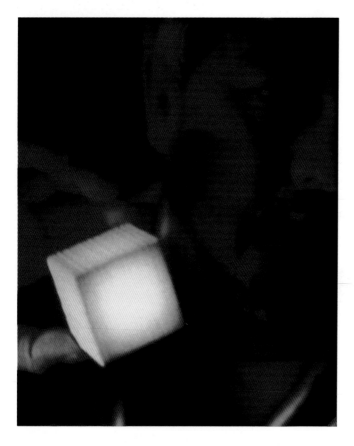

The ceramics used on the Orbiter space shuttle ⬎ tiles are excellent at dissipating heat so that, in a domestic scenario, within seconds of taking a tile from an oven, you could hold it on one of its edges while the centre would be glowing red.

The use of ceramics on the Orbiter is a unique application of an ancient material in a product of the future. The tiles thermally protect the shuttle from temperatures ⬎ between − 250°F cold in space to the 3000°F burning heat of re-entry.

This ability to withstand thermal shock is demonstrated by the fact that you could take a tile out of a 2300°F oven and immerse it in cold water without damage. As a result of this excellent thermal stability ⬎, gaps of 25mm to 65mm need to be left between the tiles and the shuttle to take account of the movement which takes place in the Orbiter's metal structure.

Dimensions	**3cm–12.5cm**
Key Features	**Near zero thermal expansion**
	Exceptionally good thermal shock resistance
	Good chemical inertness
	Lightweight approximately 93% porosity
More	**http://science.ksc.nasa.gov/shuttle /missions/missions.htm**
	www.lockheedmartin.com
	www.accuratus.com
Typical Applications	**The technology used on the tiles has been used on earth to produce vacuum-like insulation for refrigerators, furnaces and catalytic converters**

High-temperature reusable
surface insulation tiles for the
space shuttle
Developed by: Ames
Research Centre, Mountain
View, California, USA
Manufacturer: Lockheed
Missiles and Space Division

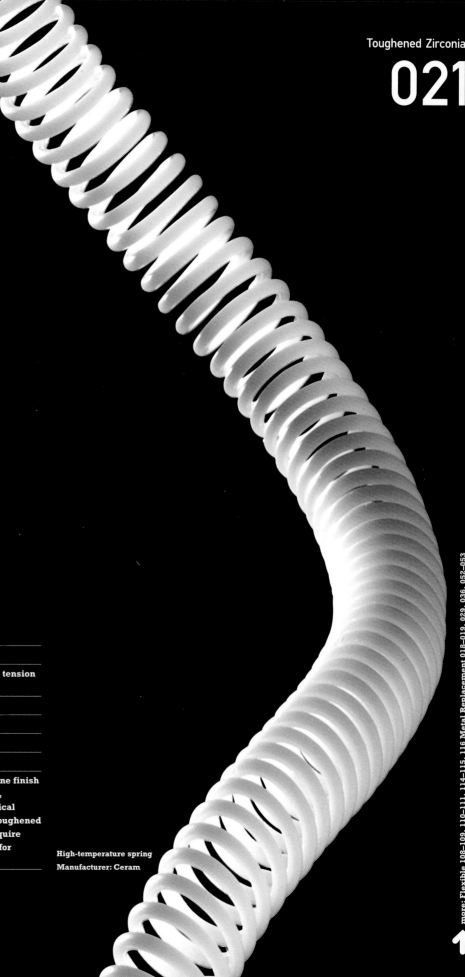

When you want to cut a piece of glass you scribe it before applying pressure and snapping it in half. The reason this works is that you are introducing a flaw in the surface, which opens up when you apply any tension. This same principle explains why ceramics are not very good under tension. But, as with all materials, ceramics can defy expectations: through a process called transformation, toughening the ceramic material can make it flexible ⬎.

The weakness in ceramics comes from the pores or gaps in the material. The reason that metals, for example, are tough is because of their ability to plastically deform. The nature of bonding of the atoms in ceramics makes them hard and strong, but it also stops them from plastically deforming. By reducing the flaw size in any material, you increase the strength.

These springs provide a unique flexibility combined with a high temperature resistance that metals would not be able to stand ⬎.

Flexible

Dimensions	**15cm x 1cm**
Key Features	**Good toughness**
	Can be used where high temperature and tension are required
	Extremely hard and durable
	Good chemical resistance
	Dense
More	**www.ceram.com**
Typical Applications	**Zirconia is known for its toughness and fine finish which make sit suitable for cutting edges, watches. Other applications include medical prostheses and pump seals, valves. The toughened form is used where these applications require extra toughness and flexibility. It is used for ceramic kitchen knives**

High-temperature spring
Manufacturer: Ceram

more: Flexible 108–109, 110–111, 114–115, 116 Metal Replacement 018–019, 029, 036, 052–053

022

Plastic ceramic

With the manufacturing characteristics of plastics, designers can produce intricate, complex shapes from this high-performance ceramic.

The US-based company Mykroy Mycalex is the producer of this glass-bonded mica. Not only is it able to be formed with plastic processing techniques like injection moulding ↘, it is also rare because it can be machined ↘ by laser-cutting, water-jet cut, CNC cut or cut using conventional metalworking tools. One of the major differences it offers over other machinable and mouldable ceramics is that, once it is moulded, it needs no firing.

Physically, it is stone-like, dense and inorganic, making a heavy clang if you tap it against metal. When it is moulded, thin wall sections can be formed and metal parts accurately inserted during processing. Moulded components have a high-quality surface finish that usually needs no further finishing, and the surface can be printed or coated for component identification.

Dimensions	1.8cm inner x 7.6cm outer diameter x 6.4cm
Key Features	**Moulds and machines like a plastic**
	No post-firing is required after machining or moulding
	Exceptional dimensional stability
	Good physical strength and impact resistance
	Good thermal shock resistance
	Does not burn or carbonise
More	**www.mykroy-mycalex.com**
Typical Applications	**The advantage of being able to mould this material means that complex components can be produced. Its ability to be machined makes it suitable for low volume production parts. The physical properties of this material make it suitable for applications where high temperature and voltage, or dimensional stability are required**

Injection-moulded high
voltage component
Grade 371 glass-bonded mica
Manufactured by:
Mykroy Mycalex

Thermal resistance

The most important characteristic of glass ceramics is their ability to withstand sudden and extreme changes of temperature ↘. Discovered by Corning ↘, who are one of the global giants of glass production, glass ceramics were originally used for missile radomes (these are the conical part at the front of a missile that allows it to send and receive information). They provided all the characteristics needed for this extreme product. The material is rugged, has an excellent resistance to heat, low thermal expansion ↘ and is good at transmitting certain types of radiation.

This was a great material but Corning saw that there was a opportunity for a product that had more of a mass appeal. So it launched a range of ovenware ↘ in the 1950s. When these glass ceramic products were first marketed to the general public, the magazine advertisements featured a range of kitchenware against a backdrop of rockets and missile shooting into space. The copy declared, 'Made of an outstanding new missile material, Pyroceram — for all its beauty, it can't crack for heat or cold.' This was the level of technological innovation attributed to this new material, branded as Corning Ware.

Dimensions	2.55cm x 9cm
Key Features	High thermal shock resistance
	High mechanical stability
	Extreme heat resistance
	Virtually no thermal expansion
	Low thermal conductivity
More	www.worldkitchen.com
	www.corning.com
	www.schott.com
Typical Applications	Its great resistance to rapid changes of extreme temperatures has made it a highly popular material for cookware. It is also used as the material for electric cooker hobs. Its industrial applications include missile nose cones, windows for coal fires, space telescopes and furnace windows

Pyrofilm dish
Distributer: World Kitchens

more: Temperatures 020, 026–027, 048–049, 108–109, 110–111, 112–113, 138–139 Corning 037 Thermal Shock 020, 030 Ovenware 046–047

024

Reactive ceramics

This is a ceramic that likes show off. When it is struck or provoked, it will react. Discovered in the 1880s by Pierre Curie, piezoelectric �‿ materials can best be described as materials that either generate a charge when deformed by hitting or bending, or change their dimension when an electric charge is applied to them.

As a sensing or transmitting element, there are many examples of piezoelectric devices in common use. The kitchen gas lighter, for example, uses them to generate a spark: a small crystal is struck which in turn generates energy in the form of a spark. A microphone works the same way, with air pressure deforming the crystals and converting the energy to a voltage, which is used to transmit sound.

Sports products are always good showcases for advanced materials. The Head ChipSystem™ tennis rackets use the reactive piezoelectric technology to produce a smart racket. At the heart of the technology are three parts: piezo reactive fibres, a circuit and a microchip. Combined, this trio takes the impact energy of the ball hitting the racket and transfers into an opposite force, thus reducing vibration.

Intelligence X Technology tennis racket with Chipsystem™
Manufacturer: Head

more: Piezoelectric 018–019, 037, 046–047

Dimensions	76cm² head
Key Features	**Motion sensitive**
	Converts waste energy
	Energy-absorbing
	Increased stiffness
	Less fibration
More	**www.advancedcerametrics.com**
	www.head.com
	www.ceramtec.com
Typical Applications	**Cigarette lighter, kitchen gas lighters, microphones, sound generating devices for sonar and ultrasound detectors. Tweeters in stereo speakers. The manufacturer ACI is currently looking into using the PZT technology to produce clothing and self-heating walking boots**

Dimensions: $76cm^2$ head

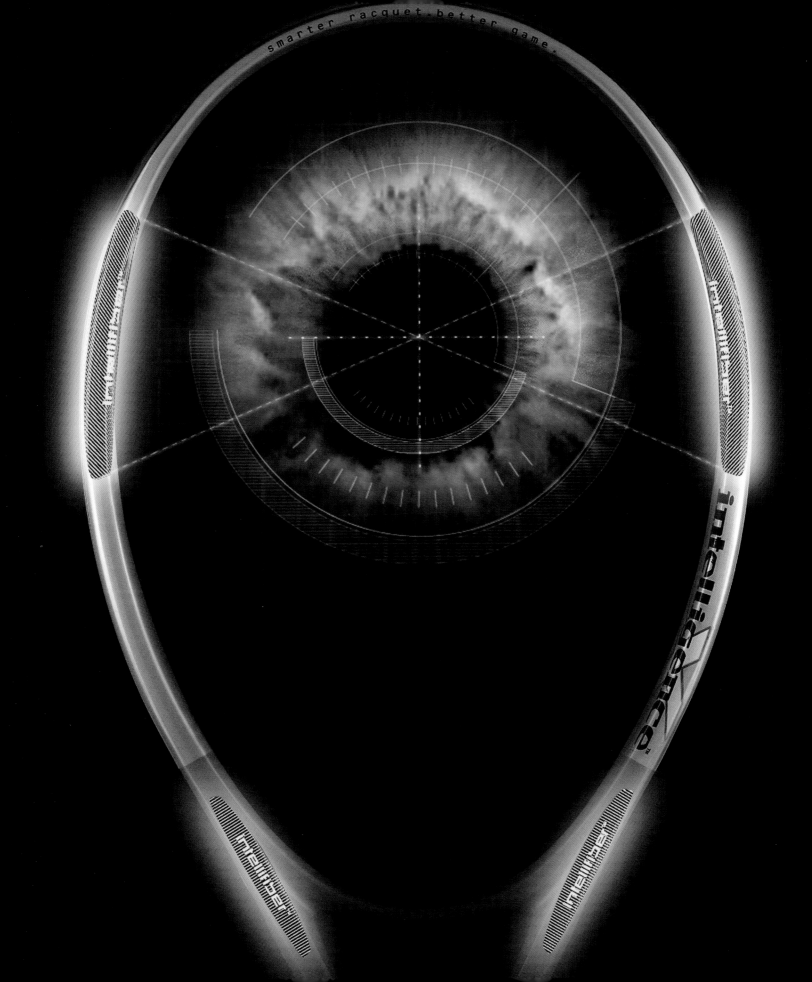

Diverse applications

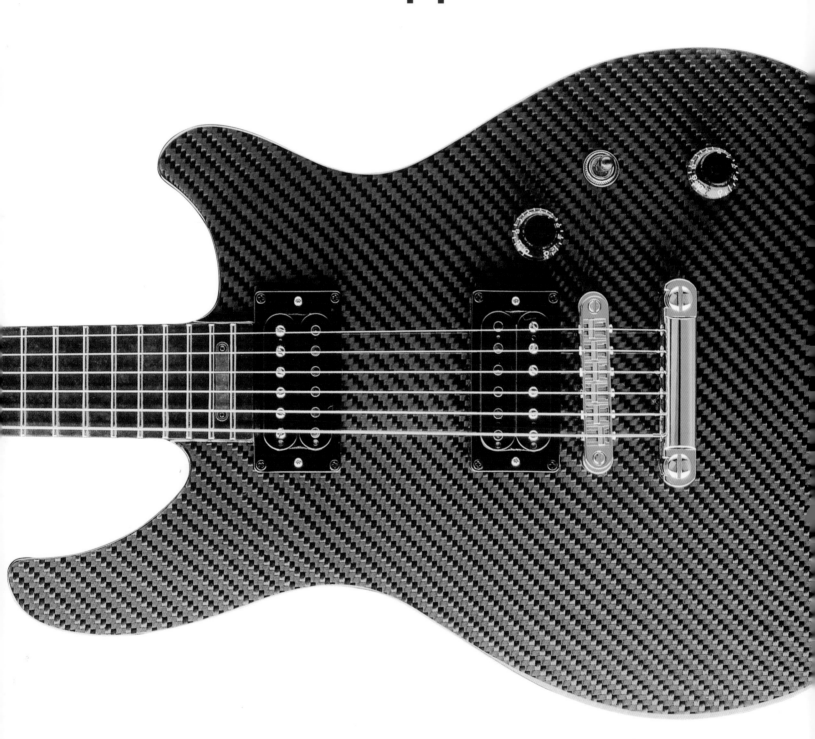

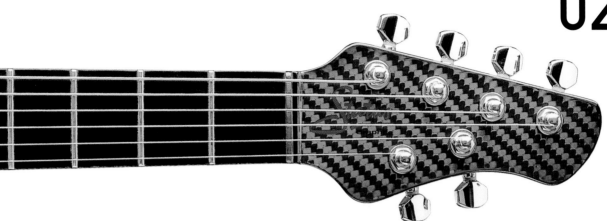

This naturally occurring mineral is not strictly speaking a ceramic, but its physical properties mean that it is often put it into this family. The uses of graphite are diverse. On a humble level, graphite makes an appearance in an everyday object like pencils, where its soft, slippery qualities are put to good use. But on a more ostentatious level, it is used for performance sports products. In these applications, it has an excellent strength-to-weight ratio, which, combined with energy-absorbing properties, makes it a contender in the market for hi-spec sports gear, like tennis racquets and golf clubs.

Characterised by its silvery grey surface with a metallic sheen, these differing applications explain how this relatively soft, slippery form of carbon is marked by three main forms: flake graphite, made up of crystal structures; amorphous graphite, which is soft and non-crystalline; and synthetic graphite, which constitutes the largest commercially used form. Graphite's layered structure gives it that distinctive, slippery feel, which provides an excellent use as a lubricant especially in high temperatures ⃕ .

The Status Graphite Guitar
One-piece carbon graphite
monocoque moulding with
compound arched top
Designer: Rob Green
Manufacturer: Status Graphite

Dimensions	**99cm x 34.5cm; weight 2.75kg**
Key Features	**Energy-absorbing**
	Good strength-to-weight ratio
	Low friction
	Non-toxic
	Good machinability
	Good resistance to chemicals
	Good electrical conductivity
	Stability and strength at high temperatures
	Excellent resistance to thermal shock
More	**www.worldwidegraphite.com**
	www.graphtekllc.com
	www.grafite.com
	www.advceramics.com/acc/products /pyrolytic_graphite
	www.ceramicindustry.com
	www.cevp.co.uk/ceramic_and_graphite.htm
	www.imerys.com
Typical Applications	**Graphite is used in its various forms in a wide range of industries. The amorphous form is mixed with clay and used for pencil leads. It is used in various composite forms to reinforce plastics improving lightness, energy absorption, strength and rigidity making it useful for performance sports goods like golf clubs, tennis rackets and hockey sticks. Its ability to withstand extremes of temperature gives it applications in products from refractors, aerospace and transport**

more: Temperatures 020, 023, 048–049, 108–109, 110–111, 112–113, 138–139

↑

028

Super-hard

Dimensions	0.7mm–2.3cm diameter
Key Features	80% lower friction than steel
	Three times harder than steel
	60% lighter than steel
	Cooler running than steel
More	www.cerbec.com
	www.nac.thomasregister.com
	www.accuratus.com
	www.precision-ceramics.co.uk
Typical Applications	The main engine of the space shuttle, military missiles, gyroscopes. Its incredible hardness provides it with a wide usage as a material for bearings such as saltwater fishing reels, racing bicycles, skates and skateboards

Silicon Nitride bearings
Manufacturer: Cerbec®

Introducing silicon nitride, one of the three hardest materials in the world. Behind diamond and cubic boron nitride ↘ in terms of its hardness, silicon nitride ↘ was developed by engineers in the 1960s who were looking for materials that could survive the hostile environment inside jet engines.

Ceramics are hard, extremely resistant to wear ↘ and offer excellent compression strength ↘. Silicon nitride offers these qualities in abundance. This is serious stuff. A dark grey/black material with a mirrored surface, 1950s science fiction writers might have imagined flying saucers made from this.

It can withstand incredible compression ↘. In the standard measurement of compression that is four million per square inch or, comparatively, the weight of 80 elephants balancing on a piece the size of a sugar cube, or a one-inch diameter cable that can lift 50 cars. And, talking smoothness ↘, if a ball bearing were the size of the Earth, the roughest peak would only be six metres high. This explains why it is so popular as a material for bearings.

Low friction

Key Features	Widely available
	Good strength and stiffness
	Hard and durable
	Can be processed in many different ways
	Good corrosion resistance
	Good thermal stability
	Can be machined
	Excellent electrical insulation
	Can be readily joined to metals
More	www.bioceramics.com
	www.jri-ltd.co.uk
Typical Applications	Alumina is one of the most widely used advanced ceramic materials. Electrical insulation on spark plugs, wear-resistant parts such as textile guides, dies, bearings and other medical prostheses. Its wide availability and range of properties also makes it suitable for electronic substrates. It is also used for making ceramic fibres and papers

Vitox alumina and
zyranox zirconia hip
replacement heads
Manufacturer: Morgan
Advanced Ceramics

Creativity comes from distilling functions down to two words: hardness and inertness. By assessing these qualities, new applications can be discovered or old materials can be replaced.

Polished to a mirrored finish ↘, ceramic hip replacements are superceding the traditional metal products ↘. Harder and more durable than metal, they provide the user with a longer-lasting, more comfortable joint.

When you rub the surface of metals, small particles of debris are produced. When two metal surfaces are rubbed together in an enclosed shape, this debris is trapped, resulting in an increase of friction between the two surfaces. After time, the joint becomes harder to use and needs replacing. The hardness of ceramic produces a surface that is less likely to wear and which maintains its smoothness ↘ and low friction under pressure from running, jumping and continual movement. The fact that it is chemically inert also means that the joint does not react with any chemicals in the body ↘.

more: Mirrored Finish 28 Metal Replacement 018–019, 021, 036, 052–053 Chemical Inertness 016, 018–019, 036, 052–053, 088–089, 114–115 Alumina 014–015, 018–019, 036, 046–047, 048–049, 052–053 Smoothness 028

030

Hard-wearing

Incredibly hard-wearing ⊾ with a very high resistance to thermal shock ⊾ is the best way to summarise and distinguish silicon carbide ⊾ material from other advanced ceramics. To get a really good idea of what it looks like, just think of the oilstones used for grinding and sharpening tools. This brutally rough and stone-like material has been used as an abrasive for grinding wheels for over 100 years. There are more functions and forms for this high-performance material waiting to be discovered through a range of processes:

Dry-pressing ⊾ to size is the most economical forming method for volumes of 300 pieces or more, which helps to justify the initial expense of tooling designed specifically for each part.

Injection moulding ⊾ is used for complex parts where dry-pressing isn't possible. Isostatic pressing is suited to low volumes and prototypes.

Slip-casting ⊾ makes thin-walled uniform shapes possible for low- and medium-volume production, while extrusion is used for high-volume, constant cross-section, long-length tubing and rod.

Machining ⊾ in the pre-sintered, or green state is often desirable because it allows manufacturing of finished shapes without expensive grinding of sintered material. Green machining is accomplished using conventional CNC lathes and mills. Final grinding is done with diamond wheels and costs increase substantially as blueprint tolerances tighten.

New developments by St Gobain researchers in the use of bonding agents and other additives now permit the mass production of complex shapes of hexoloy silicon carbide by extrusion; pressure forming, with bi-directional or isostatic presses at room temperature; slip-casting and injection moulding.

Dimensions	20.5cm x 5.5cm x 2.6cm
Key Features	**Excellent resistance to wear**
	Excellent resistance to thermal shock
	Excellent hardness
	Low density
	High strength
	Low thermal expansion
	High thermal conductivity
	High elastic modulus
	Good chemical inertness
More	**www.carbo.com**
	www.accuratus.com/silicar.html
	www.carborundumabrasives.com
Typical Applications	**Grinding media in environments where there are extreme changes of temperature. Heat exchangers and products for severe applications including conditions of high corrosion and abrasive wear**

**Silicon carbide
Sharpening Stone
Manufacturer: Carborundum**

X-ray walls

Concrete ⬎ is a material with an image problem. When you begin to discuss this dominant building material, images of grey, severe, landscapes with gritty surfaces come to mind. On first impressions, it appears neither decorative nor a medium which offers creative potential. It is structural, cost effective and possibly boring. But it is easy to ignore the phenomenal impact of this sludgy material on our modern lives and to forget the number of projects, buildings and environments that have been made possible by this amazing material. The modern world is overflowing with concrete structures.

But this is a variation of the material that brings new applications and possibilities to our buildings. American architect Bill Price has been experimenting with concrete since 1999. His preoccupation is with exploring how the material can be adapted to become translucent. His investigations aim to challenge the traditional aesthetic values of concrete, by allowing light to travel through the material in varying degrees of intensity, depending on the composition.

Aggregates, binders and reinforcements such as glass and plastic ⬎ have been incorporated into the mix to produce varying degrees of transparency, without destroying the structural integrity of the concrete.

Dimensions	Sample approximately 25cm x 50cm
Key Features	**Light transmitting**
	Offers the opportunity for integrated decorative structures
	Compression strength equal to standard concrete
More	billpprice@hotmail.com
Typical Applications	**The idea behind transparent concrete is to transform various building elements: walls, rooves columns etc. Bill Price also hopes the material could be used in baths, toilets and furniture**

Sample of glass concrete
Produced by: Bill Price

035 Objects

036

Metal replacement

The brackets used by orthodontists must be small, very strong, usable on a variety of tooth types and shapes, and be precision-tailored to a prescription specification.

For many years, metal appliances were used but many patients did not like the look of metal. In 1986, orthodontic product supplier 3M Unitek turned to ceramics as an aesthetic alternative. Ceramic material is used extensively in health care for false teeth and dental crowns ⬎, and joint replacements ⬎ because of its inherent strength and biological inertness ⬎.

Materials pioneered by NASA for the US space programme and the space shuttle ⬎ provided the basis for the ceramic material chosen for 3M Unitek's Clarity™ brackets. Using a special blend of Translucent polycrystalline alumina (TPA), Clarity™ brackets are produced by pressing powdered alumina ⬎ into a bracket-shaped die, sintering (heating without melting), and then machine finishing for smoothness and accuracy. To give metal-like performance characteristics, the design incorporates a metal slot liner that works with the metal archwire used in orthodontic treatment.

Today, Clarity™ ceramic brackets are usable whenever metal brackets are prescribed. The advantage is the highly translucent appearance of the bracket. In addition, the ceramic material in the brackets will not stain or discolour when encountering many food that often stain teeth, such as coffee, tea and soft drinks.

Key Features	Wear-resistant
	Good corrosion resistance
	Chemically inert
	Good strength
More	www.3m.com/unitek
Typical Applications	Alumina is one of the most widely used and advanced ceramics. Electric insulation on spark plugs, wear-resistant parts such as textile guides, dies, bearings and other medical prostheses. Its wide availability and range of properties also makes it suitable for electronic substrates. It is also used for making ceramic fibres and papers

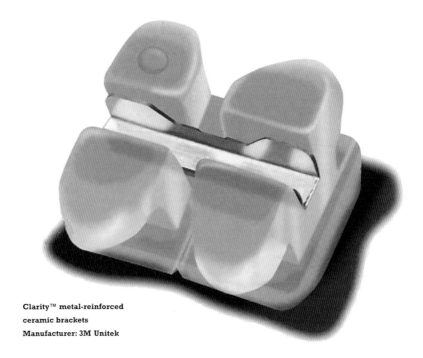

Clarity™ metal-reinforced
ceramic brackets
Manufacturer: 3M Unitek

Honeycomb structure

From the piezoelectric ↘ in the car stereo speakers and the alumina spark plugs ↘ in your engine, to the oxygen sensors, which use a form of electrically conductive zirconia ↘. From silicon carbide ↘ seals in the water pump to magnets ↘ in the various motors around an average vehicle, there is no end to the number of components in a typical car that are made from ceramics.

At the heart of the pollution control system is the catalytic converter. Ceramics offer the advantage of being lightweight, with an excellent resistance to wear and temperature, making them an ideal material for the extreme environment near a car engine.

Most catalytic converters have a honeycomb structure coated in a layer of a metal catalyst which encourages a chemical reaction to occur, turning the poisonous carbon monoxide, nitrogen oxide and soot into water, nitrogen and carbon dioxide. The most interesting aspect of these products is their incredible structure: the honeycomb offers the highest possible degree of surface area for the catalyst to optimise its efficiency. Yet these products are amazing feats of manufacturing, with structures containing an incredible 900 cells per 2.5cm^2, with wall thicknesses of less than 0.14mm.

Cordierite ceramic catalytic
Manufacturer: Corning

Dimensions	1015 cells per cm^2; 6.5mm walls
Key Features	**Resistant to corrosion**
	High strength-to-weight ratio
	Resistant to wear and temperature
	Large surface area due to honeycomb structure
More	**www.corning.com/environmentaltechnologies**
Typical Applications	**Extreme environments in engines**

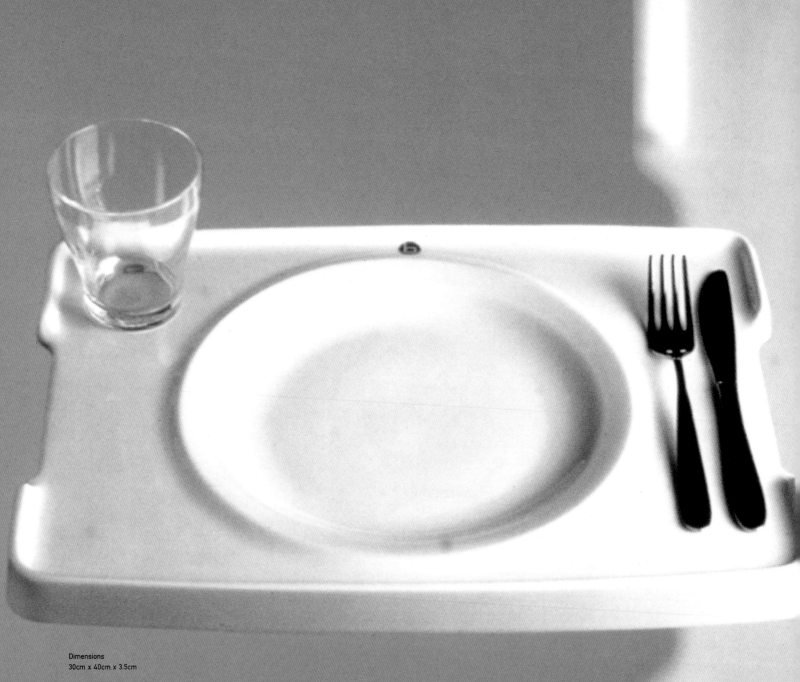

Dimensions
30cm x 40cm x 3.5cm

TeeVee Plate/Tray
From the Ceramix Collection
Designer: Bastiaan Arler
Manufacturer: Britefuture
Design date: 1999

Accessible production

Ceramics are accessible. From high-volume mass production to one-offs they can be easy to form and approachable on both production and cost criteria. There isn't the need for high-cost moulding tools unless you want them, and single or batch pieces can easily be produced without breaking the bank.

Bastiaan Arler is a designer who used these traits as a starting point for his entry into the design world. His collection of tabletop products that exploit the production advantages of earthenware ⇘ ceramics to build a unique family of branded products.

Plates ⇘ on a tray are a part of every day life, not just TV dinners but also with canteens, fast food and airline meals. The plate and the tray have become fused together through habit, so why not make it a permanent marriage. This polar white plate morphed into a tray not only brings together two product typologies, but also confirms the point by blending the traditional crockery used for plates into the form of the tray.

Key Features	**Low-cost production**
	Ideal for mass production
	Less distortion during firing than procelain or china
	Cost-effective
	Relative ease of production
	Low firing temperature
More	**www.britefuture.it**

Dimensions
33cm x 13cm

**Eero table mats from the
Ceramix Collection
Designer: Bastiaan Arler
Manufacturer: Britefuture
Date: 2002**

Dimensions
20cm x 4cm

**Em and Em candle holder from
the Ceramix Collection
Designer: Bastiaan Arler
Manufacturer: Britefuture
Design date: 1999**

more: Earthenware 046–047, 054–055, 074–075, 082–083, 092–093

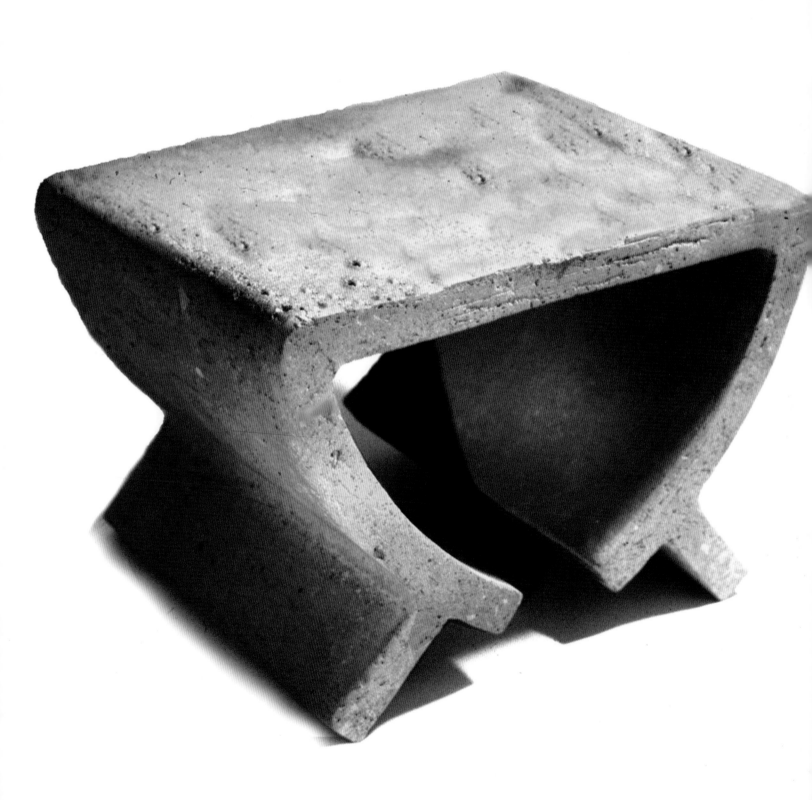

Weather-resistant

Humpty Dumpty sat on the wall,
Humpty Dumpty had a great fall,
All the King's horses
And all the King's men
Couldn't put Humpty together again

What happens if you bring two unrelated elements together at the beginning of a design brief? In this case, a table and a nursery rhyme about Humpty Dumpty were the starting points in a project which explored a new process towards designing a table.

'Working together as design lecturers, we wondered how to provide a project structure for our students while showing them a more tangential, creative approach to design,' says Chris Lefteri. We had two goals: first, create an abstract framework in which no shape, composition, material or manufacturing process was preconceived; second, we wanted to show that once the groundwork is down you do not have to create the answers yourself but that the answers will hijack you along the way.

'A final question for us stemmed from our own efforts to create work for ourselves by applying materials and manufacturing methods to established industries. By breaking down nursery rhymes, abstract frameworks of ideas, functions and emotions are created. Ceramic was chosen as an appropriate material for the table because of the wall ⬂ Humpty was sitting on and because it shared the fragility of Humpty Dumpty. The extruded ceramic technique proposed for the manufacture of the table breaks ground in the creation of furniture ⬂, while using one of the oldest materials available to mankind.'

Dimensions	50cm x 45cm x 34cm
Key Features	**Distinctive surface**
	Weather-resistant
	Excellent compression strength
More	**www.hgmatthews.com**
	dominicj1969@aol.com

Humpty Dumpty,
Brick Clay Table
Designers: Dominic Jones,
Chris Lefteri
Manufacturer: Batch
production by Lorraine Rutt
Date: 1996

more: Wall 014–015, 028, 032–033, 104–105 Furniture 060–061, 068–069, 076–079, 091, 094–095

042

Acoustic ceramics

Until relatively recently, most speakers have been shy to come out from behind the sofa or from the corner of the room. But these speakers are part of a new generation, ambitious enough to decorate the ceiling.

The experimentation of new materials for speaker design is an ongoing process. We have already seen glass speakers, but here we have a material that allows this product typology to be stretched even further. This material crossover not only brings improved acoustic performance to the technology, but also brings new functional meanings that allow the product to live in a new context.

This story begins with Francesco Pellisari, a 34-year-old Italian acoustic designer who, on a visit to Umbria, the heart of Italy's ceramic industry, caught sight of a discarded ceramic cone. Pellisari's tests found that the rigidity of ceramics could be applied to speakers: the rigidity enhances the frequency on the sounds. For the Seth range of speakers, the terracotta is fired at a high temperature and a glaze is applied. The platinum coat ⇘ is applied on the third firing over the glaze.

These speakers are not just new materials in an old context but extend the use of a new material, finding new decorative potential and new locations for the black box that sits in the corner of a room.

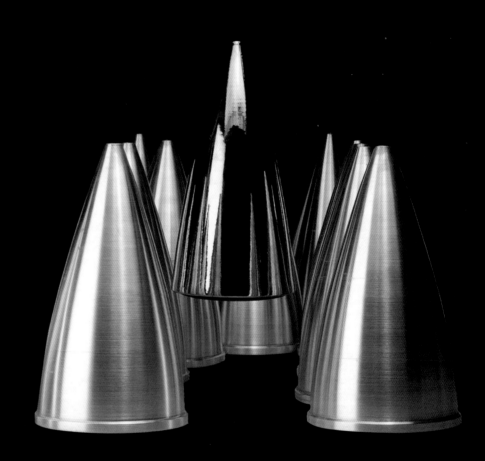

Key Features	Cost-effective
	Low density
	Fine, distinctive surface
	Can be formed with a variety of production methods
More	www.nacsound.com

Dimensions
32cm x 14cm diameter

Seth speaker in
platinum-plated ceramic
Designer: F. Pellisari
Manufacturer: NAC
Sound Srl, Italy
Date: 1999

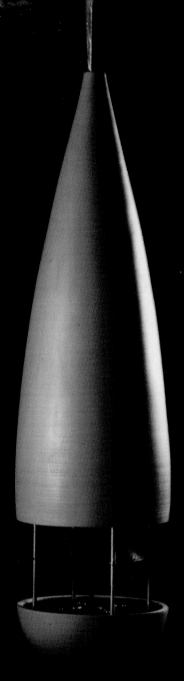

Dimensions
81cm high

Atun speaker
Designers: Elizabeth Frolet
and F. Pellisari
Manufacturer: NAC
Sound Srl, Italy
Date: 1996

more Platinum 130–131, 132–133

↑

044

Ceramic and plastic

Dimensions	6.5cm x 10cm diameter
Key Features	Chemically inert
	Dishwasher-safe
More	www.guzzinifratelli.com

Feelings tableware
Designer: Queensberry Hunt
Manufacturer: Guzzini Fratelli
Date: 1998

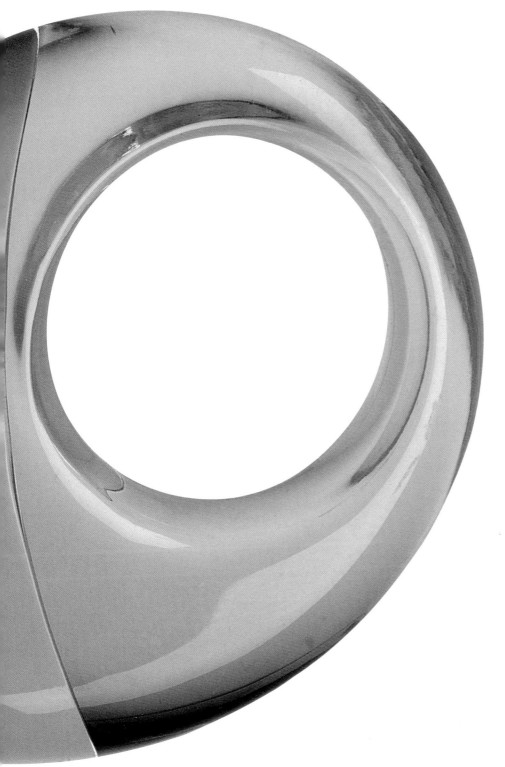

The design brief: to help a well-known manufacturer of modern plastic products bring a new sense of formal dining to plastic when most people think of plastic as a disposable medium only used for picnic sets?

The solution was provided by well-established British design consultancy Queensberry Hunt. The final range, known as Feelings, bridges the gap between the two very different associations of the porcelain ↘ cups and the Styrene Acrylonitrile (SAN) polymer handles, producing an exciting encounter of two materials. The end products are unique not only in the combination of materials ↘, but also in the nature of the their visual qualities. The jewel-like plastic is offset against the purity of the ceramic, and they're dishwasher safe.

It terms of fixing two materials like these together, it is not an issue of finding the strongest glue but of finding an adhesive that will provide the right degree of flexibility of movement between the two materials which expand and contract at different rates.

Bamboo-coloured

Many high-tech materials have made an entry into our kitchens: glass ceramic hobs and dishes ⬎, piezoelectrics ⬎ in gas lighters, printed alumina ⬎ in the microwave – but these products refer to a different type of appeal within ceramics.

These traditional Caneware mixing bowls have a nostalgic quality, reminiscent of Grandmother baking cakes on a Saturday afternoon. The bowls encourage you to cradle them in your arms. These traditional glazed earthenware bowls have remained virtually unchanged for over 100 years. The distinguishing features of this bowl are the warm, stodgy colour of the Derbyshire clay and the gentle relief pattern. Caneware derives its name from its colour, due to its resemblance to bamboo.

There are many classic products which are distinctly ordinary in design but which hold special associations and meanings. They characterise a certain relationship we have with some ceramics, the closeness, the everyday, the kind of friendly persona they can take on. This is not the high-tech world of advanced materials but the cosy comfort of everyday earthenware.

Dimensions	**11.5cm–40cm diameter**
Key Features	**Cost-effective**
	Less distortion during firing than porcellain or china
	Chemically inert
	Relative ease of production
More	**www.masoncash.co.uk**

Caneware mixing bowls
Manufacturer: Mason Cash
Date: 19th century

more: Dishes 023 Piezoelectrics 018–019, 024–025 Alumina 014–015, 018–019, 029, 036, 048–049, 052–053, 082–083, 098–099, 118–119 Earthenware 038–039, 054–055, 082–083
Plates 038–039, 092–093

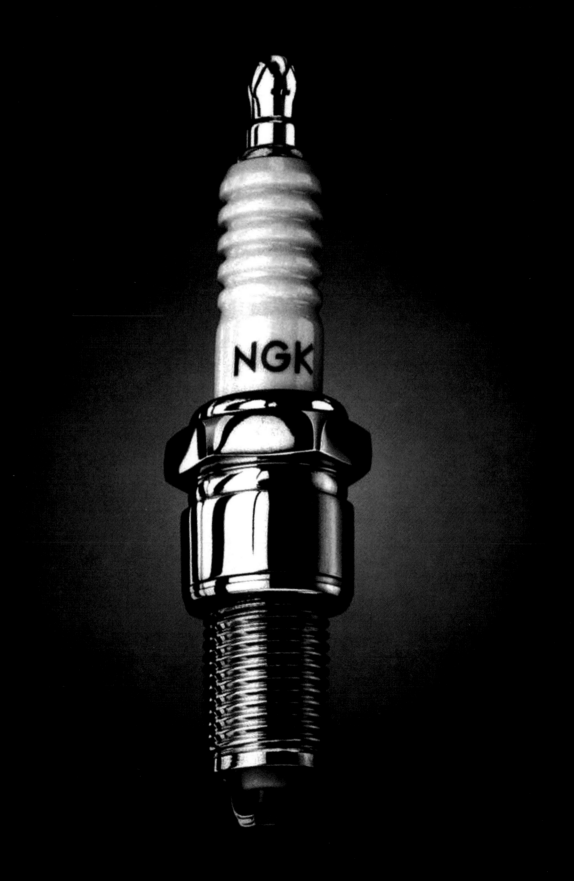

Electric blanket

Spark plugs are one of the pioneers of advanced ceramics. The importance of these engine slaves, and their development alongside new methods of transport, have helped advance ceramic technology to new frontiers. These common and essential components of modern engines offer an everyday, familiar example of one of the key advantages of ceramic materials: its ability to withstand harsh, extreme environments.

When car production began in the 19th century, manufacturers needed a way to produce a spark for the new internal combustion engines. Materials were needed to stand up reliably to the extreme environment of the engine. The environment around the spark plug was exposed to high voltages, vibration and physical shock and would alternate between bursts of extremely high temperatures ⬆.

The early spark plugs were not reliable and needed replacing frequently. The early half of the 20th century saw continual research into new materials and production methods for this valuable component. This in turn pushed engineers and scientists to come up with new formulas. Early materials like porcelain ⬆ were fabricated on a potter's wheel, but these proved to be unreliable. Alumina powder ⬆ was used as a replacement for clay, which required a new production method of compression moulding.

Spark plug with copper core
Manufacturer: Bosch

Dimensions	7.8cm x 2.4cm
Key Features	Good electrical insulation
	Good heat resistance
	Chemically inert
	Hard and wear-resistant
More	www.morganceramics.com
	www.bosch.com
Typical Applications	Automobiles, boat engines and lawnmowers. High-voltage insulators make it possible to safely carry electricity to houses

more: Temperatures 020, 023, 027, 108–109, 110–111, 112–113, 130–131, 138–139 Porcelain 044–045, 054–055, 056–057, 060–061, 062–063, 066–067, 070–071, 072–073, 088–089, 090, 124–125, 128–129 Alumina 014–015, 018–019, 018–019, 029, 036, 046–047, 052–053, 070–071, 108–109, 110–111, 112–113

Warm

There is an emotional aspect to ceramics, which is harder to define than its physical properties — hardness, chemical inertness or high temperature resistance. This is a material that has an everyday presence that we use without a second thought. We encounter and experience it on an unconscious level — its hardness, its glassyness, its decoration when we eat from our plates, drink from our mugs ⌄ or sip from our bone china tea cups ⌄. This mug by Pepe Garcia Zaragoza picks up on these sensitivities.

He explains: 'This is a mug that speaks more about warming yourself up than about drinking. Often you go for a tea or a coffee not because you are thirsty, but because you are cold. The mug transforms itself due to this new requirement (to control the heat), finding a new typology. You can feel the heat of your drink through the bottom of the mug, so it becomes a hand warmer more than just a container.'

The terracotta ⌄ is slip-cast ⌄ using a complicated two-part plaster mould with a mobile insert to create the double-walled production. The bottom piece that closes the mug is added at the end of the process from another mould.

Dimensions	14cm x 10cm base diameter
Key Features	Cost-effective
	Easy to form with a variety of production methods
	Low firing temperature
More	unpepe@hotmail.com

Winter Mug
Designer: Pepe Garcia Zaragoza
Date: 1999

more: Mugs 092–093 Bone China 062–063 Terracotta 064, 065, 078–079 Slip-casting 030–031, 056–057, 060–061, 064, 066–067, 074–075, 091

052

Stays sharp

So why have a ceramic sharp edge in your kitchen? Why should you want to ditch those steel graters in favour of a high-tech ceramic material? There are several reasons why manufacturers will tell you ceramics are better, but the main reason lies in their characteristically hard-wearing quality, which means they will stay sharp for longer ⟍.

Within many areas of manufacturing, ceramics have taken the place of steel tools ⟍. For example, ceramic pressing for punching out aluminium drinks cans. This improves efficiency and cost effectiveness of production, allowing for tools to last 20 months without signs of wear, compared to two months for traditional metal tools.

Compared with traditional steel blades, ceramics are much harder. After time the edge of a forged metal blade, which is relatively soft in comparison, will 'roll', lose its edge and need to be sharpened. The harder ceramic blades will remain sharp for much longer. The chemical inertness of ceramic also means that it won't react with your food ⟍.

Kyocera ceramic grater
Manufacturer: Kyocera

Dimensions	8.9cm and 16.5cm diameter
Key Features	Hard-wearing
	Chemically inert
	Stays sharp
	Cost-effective production
More	www.kyocera.de
	www.kyoceraTycom.com
	www.kyocera.co.jp
	www.sorma.net

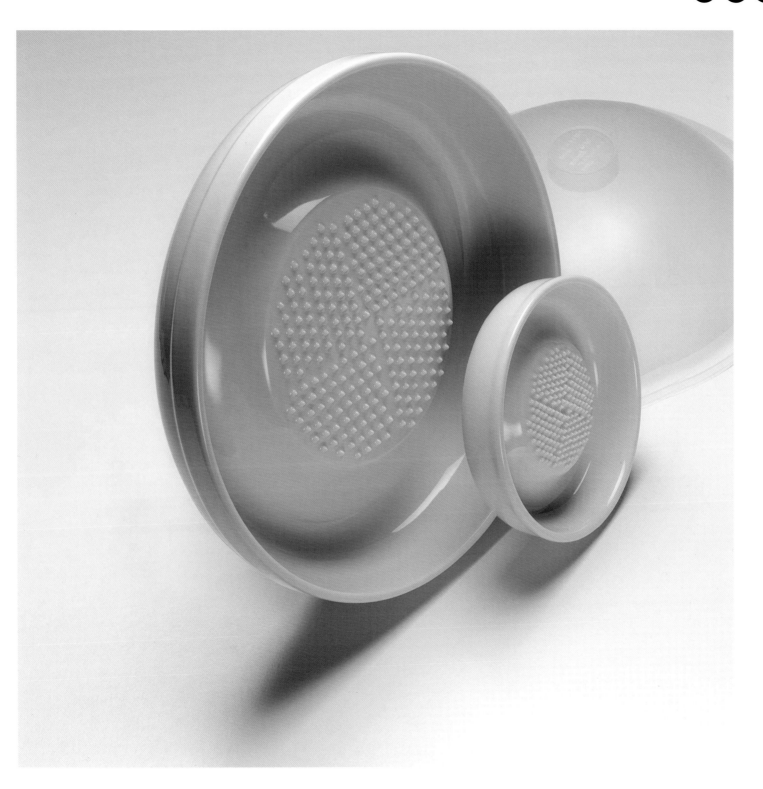

more: Metal Replacement 018–019, 021, 029, 036 Chemical Inertness 016, 018–019, 029, 036, 088–089, 114–115 Alumina 014–015, 018–019, 029, 036, 046–047, 048–049, 108–109, 110–111, 112–113 Zirconia 017, 018–019, 037, 118–119

054

Dimensions
12cm x 15cm diameter.
9cm x 25cm diameter

Perforated containers
Designer: Stefanie Hering
Manufacturer: Hering Berlin
Date: 2002

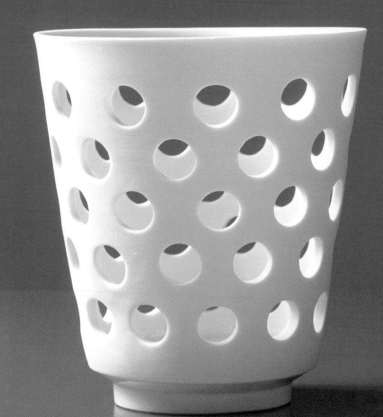

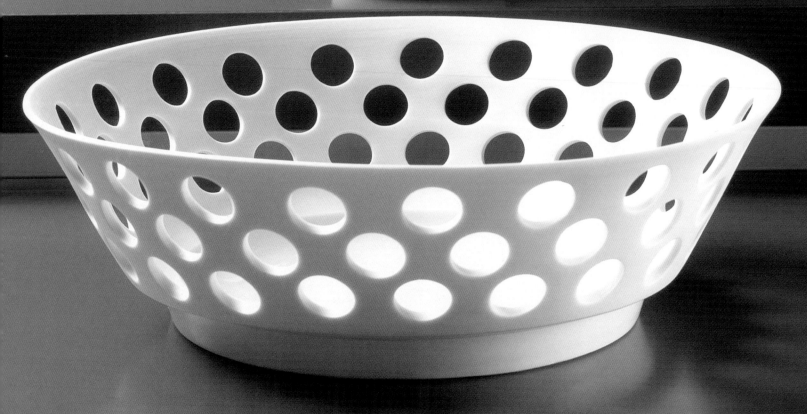

Hard and translucent

Most of us know porcelain ⬎ as a distinctive material used for high quality tableware. But this blend of clay, quartz ⬎, feldspar and kaolin has uses and applications spread over a range of industries. Here it is used for its chemical and electrical properties rather than its aesthetic charm.

However for its use in more domestic products, the hard nature of this highly vitrified ceramic has allowed designers to create objects that can have fine, thin wall sections and delicate detailing without the risk of the piece being easily broken, which might be the case with earthenware ⬎. Apart from the hardness its other distinctive feature, which is also common with bone china, is its elegant translucency.

The products of the Hering Berlin porcelain manufacturer are a body of work that tests these properties. The designs rely on the gentle forms and surface of this pale material. The products play with a subtle surface finish, patterns are created that alternate between matt and partly glazed surfaces, and fine changes of opaqueness and translucency. These are objects which play to the precious nature of the material, exploring the potential for its fine, paper-thin edges.

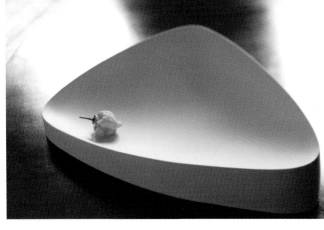

Dimensions
Stadium 42cm x 24cm

Stadium
Designer: Stefanie Hering
Manufacturer: Hering Berlin
Date: 2000

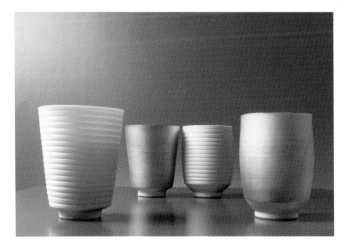

Dimensions
9cm x 8cm diameter

Porcelain cups
Designer: Stefanie Hering
Manufacturer: Hering Berlin
Date: 2002

Key Features	**Translucent**
	Fine
	Very hard
	Chemically inert
More	**www.hering-berlin.de**

more: Porcelain 044–045, 048–049, 056–057, 060–061, 062–063, 066–067, 070–071, 072–073, 088–089, 090, 124–125, 128–129 Quartz 062–063, 120–121
Earthenware 038–039, 046–047, 082–083

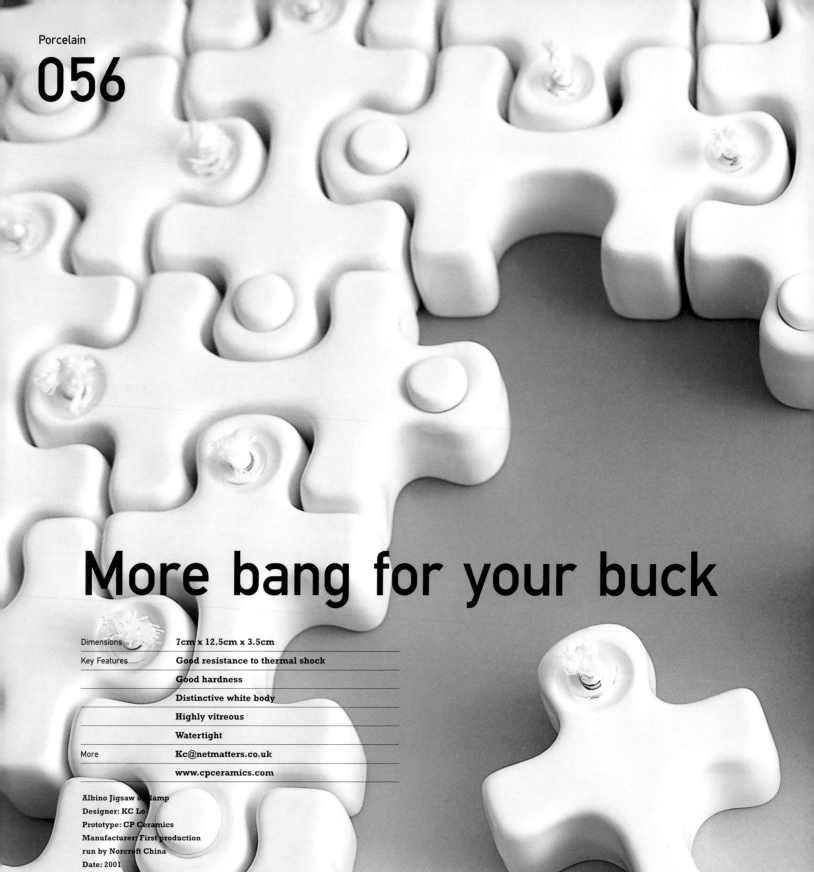

More bang for your buck

Dimensions	7cm x 12.5cm x 3.5cm
Key Features	Good resistance to thermal shock
	Good hardness
	Distinctive white body
	Highly vitreous
	Watertight
More	Kc@netmatters.co.uk
	www.cpceramics.com

Albino Jigsaw oil lamp
Designer: KC Lo
Prototype: CP Ceramics
Manufacturer: First production
run by Norcroft China
Date: 2001

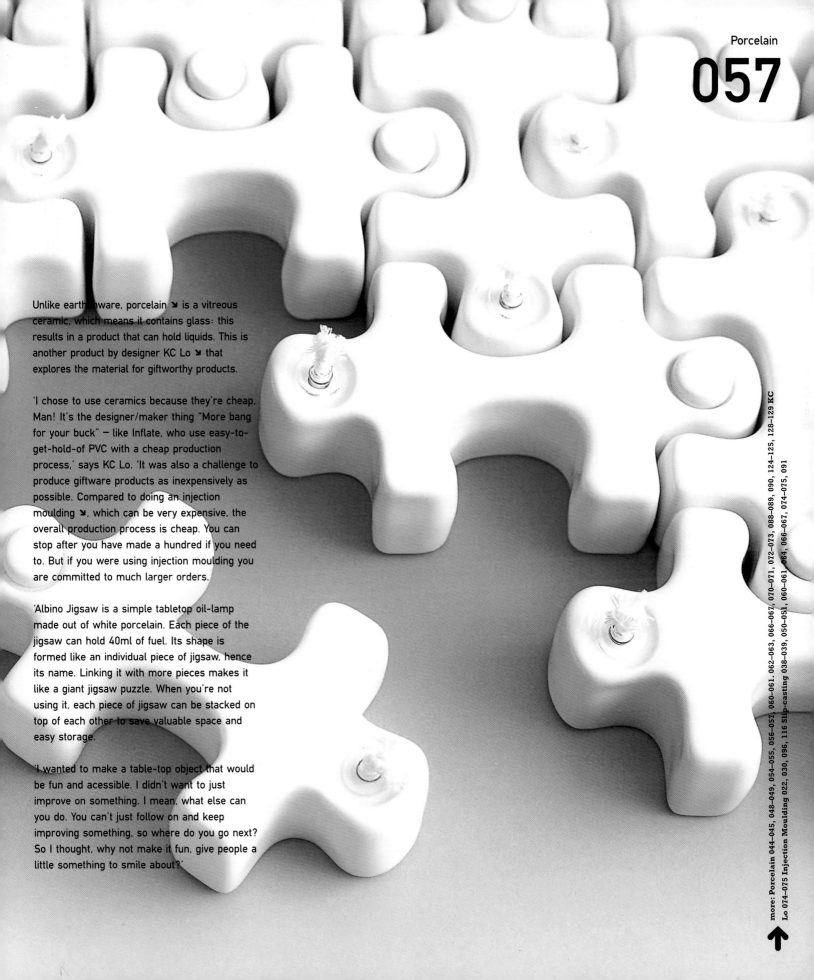

Unlike earthenware, porcelain ⬎ is a vitreous ceramic, which means it contains glass: this results in a product that can hold liquids. This is another product by designer KC Lo ⬎ that explores the material for giftworthy products.

'I chose to use ceramics because they're cheap. Man! It's the designer/maker thing "More bang for your buck" — like Inflate, who use easy-to-get-hold-of PVC with a cheap production process,' says KC Lo. 'It was also a challenge to produce giftware products as inexpensively as possible. Compared to doing an injection moulding ⬎, which can be very expensive, the overall production process is cheap. You can stop after you have made a hundred if you need to. But if you were using injection moulding you are committed to much larger orders.

'Albino Jigsaw is a simple tabletop oil-lamp made out of white porcelain. Each piece of the jigsaw can hold 40ml of fuel. Its shape is formed like an individual piece of jigsaw, hence its name. Linking it with more pieces makes it like a giant jigsaw puzzle. When you're not using it, each piece of jigsaw can be stacked on top of each other to save valuable space and easy storage.

'I wanted to make a table-top object that would be fun and acessible. I didn't want to just improve on something. I mean, what else can you do. You can't just follow on and keep improving something, so where do you go next? So I thought, why not make it fun, give people a little something to smile about?'

059 Traditional

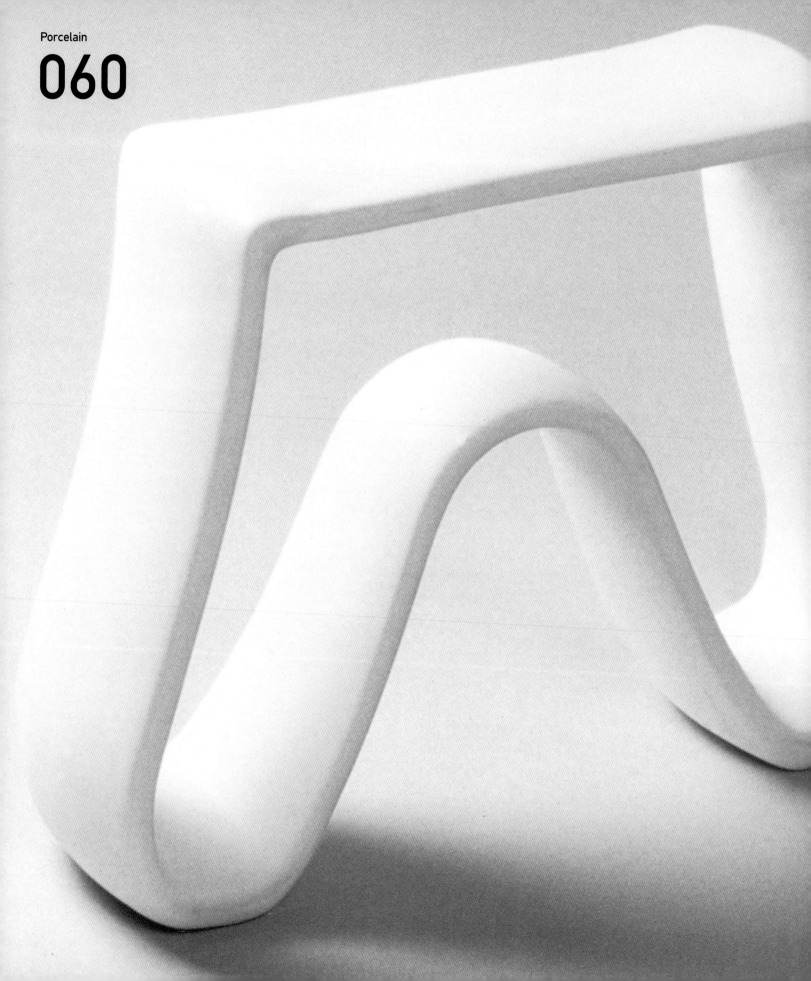

New applications

Porcelain ⬎ is one of those materials loaded with a rich history associated with high-quality tableware and ornate figurines. Characterised by its whiteness, hardness, its ability to produce delicate forms and its ghostly translucency, porcelain was first discovered around 600 AD in China. This is why it is often referred to as china or chinaware and it was not until the 18th century that Europeans were able to replicate it. Apart from being used for expensive dinner services, porcelain has also been one of the main ceramics used to produce electrical insulators and spark plugs ⬎.

In 1996, design group Droog were invited by Rosenthal, the well-known German porcelain manufacturer, to take part in an experimental project to find new applications and uses for this valued material. The result of this led to a family of freethinking trials with this ancient material, which are not restricted to its familiar use as tableware. The group of products includes furniture ⬎, tableware and lighting. The pieces include experimental production methods and new product typologies, and new combinations of ceramics with other materials ⬎.

Dimensions
50cm x 40 cm x 25cm

Prototype porcelain stool
Designer: Hella Jongerius
Manufacturer: Rosenthal
Date: 1997

Dimensions
10 x 10cm, 12 x 12cm, 14 x 14cm

Eggshell vase
Designer: Marcel Wanders
Manufacturer: Cappellini
Date: 1997

Dimensions
8cm x 12cm diameter

Sponge Vase
Designer: Marcel Wanders
Maufacturer: Cappellini
Date: 1977

Key Features	**Good hardness**
	Good resistance to physical shock
	Translucent quality
	Distinctive white body
	Good abrasion and wear resistance
More	**www.rosenthal.de**
	www.droogdesign.nl
Typical Applications	**Dental brackets and crowns, electrical insulators, tableware, decorative figurines**

062

Bone ash

Yes it is true, bone china �î takes its name from the fact that 50% of its formula is made up of bone ash, with 25% kaolin (china clay) and 25% mixture of quartz ⬎, feldspar (china stone) and mica. It was invented as a result of Europeans trying to reproduce porcelain ⬎ brought over from China, where it has been used for over a thousand years.

When porcelain was first brought over by traders in the 12th century, Europeans found the beautifully fine, hard and translucent characteristics of this new material truly unique. However, it took them many years to copy its recipe. The result of this search came in the 19th century in Staffordshire, England, where someone mixed the ashes of animal bone with kaolin and china stone to produce bone china, which had similar properties but could be produced by existing methods.

Although both bone china and its close relation porcelain are hard, white and translucent, they are different materials and thus require different processing. The vitrified nature of bone china helps to give it its hardness, which is why it is possible to make thin, fine wall thickness and details. It also helps with its resistance to moisture. All varieties of bone china are distinct from porcelain by being a slightly different shade of white. Both are translucent but china is slightly creamier. Porcelain and china have become synonymous with quality and luxury.

Amberst bone china tea cup
Manufacturer: Wedgewood

Dimensions	7cm x 8.5cm diameter
Key Features	Biscuit-fired at around 1200°C
	Good strength
	Translucent
	In its pure form is white
	Resistant to water
	Has a higher biscuit-firing temperature than porcelain
	Can be glaze-fired at a lower temperature
More	www.wbb.co.uk
	www.wedgewood.com
Typical Applications	This high-grade English pottery is used for various tableware products. China clay however is used for making the various forms of porcelain: an abrasive powder; a refractory material; electrical insulators; a pigment in paints; and filler for plastic mouldings to reduce moisture absorption

→ more: Bone China 050–051, 066–067 Quartz 054–055, 120–121 Porcelain 044–045, 048–049, 054–055, 056–057, 060–061, 070–071, 072–073, 088–089, 090, 124–125

Thermal insulation

Siesta is a product with a foot firmly placed in the history of Spanish water carriers. Based on the Botijo, this iconic shape has been updated, inspired by modern plastic water bottles.

Héctor Serrano explains: 'We used white terracotta ⬎ from the Alicante region in Valencia. This material has no added colouring or glaze, just a small portion of salt, which helps keep the water cool, even when the sun is hot. Depending on which region in Spain the terra cotta comes from it will look different.

'The Botijo was used by workers is Spain to carry water from their homes to the fields where they worked. The Botijo keeps water cool in the heat of the sun. It has two holes, one for filling and one for drinking from. The larger hole can also be used to pour water into a jug or cup. The hole at the top is used to carry and hold the container.

'They were traditionally made by hand, using lathe production ⬎ to make a small batch. It has since been sold to a manufacturer and is now slip-cast ⬎.

'Originally 30 pieces were made at a time. Now the design is being mass-produced and they make approximately 7000 pieces a year.'

Siesta
Designers: Héctor Serrano,
Alberto Martinez,
Ricky Martinez
Manufacterer: La Mediterranea
Date:2000

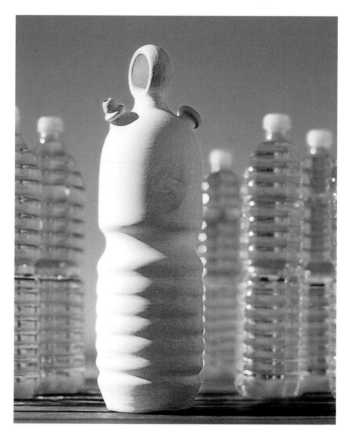

Dimensions	36cm x 10cm diameter
Key Features	**Easily formed**
	Weather resistant
	Good thermal protection
	Low temperature firing
	Low density
More	www.la-mediterranea.es
	www.hectorserrano.com
	hector@hectorserrano.com

Biscuity texture

Terracotta ⬎ is one of the simplest expressions of ceramics. It is a clay with an unglazed, semi-fired body and, with its distinctive colour and ability to withstand weathering, it is the choice for outdoor ceramics. The dry, dusty, biscuity texture of terracotta is obtained through washing the clay and mixing in fine particles of sand. Although the creamy red variety is the most common, it is also found in yellow and even a milky white.

The insulating properties of terracotta inspired this range of flowerpots by French designer Martin Szekely. The form reflects the monastic nature of this undecorated material where the only decoration is the trace of the potter's fingers.

This project was part of a larger proposal by designers in the French Vallauris region near Nice. Since 1998, two designers have been invited each year to breathe new life into this indigenous material.

Dimensions	49cm x 41cm diameter, 39cm x 31.5cm diameter,
	30cm x 27cm diameter
Key Features	Cost-effective
	Fine and distinctive surface
	Weather-resistant
	Can be formed by a range of production process's
	Low density
More	www.kreo.com
	www.martinszekely.com
Typical Applications	Floor and roofing tiles; building bricks; ornamental building parts

Vallauris flower bricks
Designer: Martin Szekely
Production: Lou Pignatier
Edition: Kreo
Date: 1998

Dimensions
30cm wide

**Sage, cane, lilac and black
jasper bowl
Designer: Kathryn Hearn
Manufacturer: Wedgwood**

Strata-casting

There are many references you can make with these pieces: they look like pieces of stone that have naturally weathered; like land that have been eroded to reveal layers of evolution or even sticks of rock that you might find at an English seaside resort.

Designer Kathryn Hearn has used Jasper stoneware to produce a range of pieces combining it with a unique production process, which explores new possibilities for this traditional Wedgwood ⬎ ceramic. Through a process of slip-casting ⬎ several layers, a strata of different colours is formed which are then exposed through various methods. This process is about opening up the ceramic surface to reveal a multi-layered texture.

'I have made decorative pots and used moulds of many types, even casting into sand, but usually I work with simple plaster moulds where I can create surfaces that are intriguing and integral to the form. I make complex patterns which are achieved by putting striated inclusions into the mould before casting, also carving back the surface to reveal intimate landscapes,' says Hearn.

The name stoneware does a good job at suggesting the qualities of this kind of material. Like porcelain ⬎ and bone china ⬎, stoneware is a hard, water-resistant ceramic. The British tableware manufacturer Wedgwood uses it in a specific form known as Jasper, which is marked by its distinctive rough, stone-like textured finish.

Key Features	Not as easy to work as a clay but more stable in the firing
	Vitrified
	Fires at 1183°C
	Hard
	Opaque
	Stone-like quality
More	www.wedgwood.com
	k.hearn@csm.linst.ac.uk
Typical Applications	The hard and vitrified nature of stoneware means it has applications for water-resistant tableware without the need for glazing

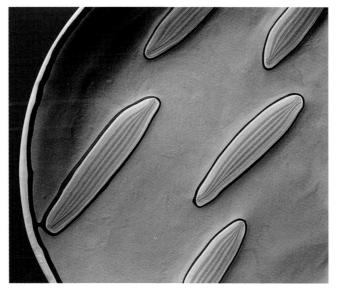

Dimensions
25cm high

**Small slipped vase with carved
recesses in Portland blue, pale
blue and stone jasper
Designer: Kathryn Hearn
Manufacturer: Wedgwood**

more: Wedgwood 062–063 Slip-casting 030–031, 050–051, 056–057, 060–061, 064, 074–075, 091 Porcelain 044–045, 048–049, 054–055, 056–057, 060–061, 062–063, 066–067, 070–071, 072–073, 088–089, 090, 124–125, 128–129 Bone China 060–061, 062–063

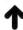

Fibre Cement

068

Loop Chair
Designer: Willy Guhl
Manufacturer: Eternit AG
Designed: 1954

Dimensions	54.5cm x 54.5cm x 76.5cm
Key Features	**Allows for thin wall sections to be constructed**
	Excellent chemical resistance
	Scratch-resistant
	Will not support or maintain mould growth or fungi
	Light-weight
	Wide colour range
	Scratch and abrasion resistant
	Life expectancy of at least 50 years
More	**www.eternit.co.uk**
	www.twentytwentyone.com
	www.eternit.ch
	www.wohnbedarf.ch
Typical Applications	**This product is mainly used in the building industry for external and internal wall cladding and roofing**

Cement sheet

These smooth, organic forms contrast with the rough, imperfect and grey cement ⊾ from which they are formed. The reference to a building material is clear: take the properties of a construction material — strong, cheap and weatherproof — and use them to create a new language for outdoor furniture ⊾.

A product of 1950s building technology, the concrete garden chair exploits the process of fibre cement, a process used to produce machine-made slabs for use in architecture. Originally reinforced using asbestos fibre, the material has since been replaced with cellulose fibres as a supporting substructure, which strengthens the material both in compression and tension.

Eternite is a patented sheet material used for walls and cladding. It is a mixture of cement and fibreglass, which allows for thin wall sections. The chair is produced as a sheet and folded around a mould.

The concrete chair is encountering a renaissance as a contemporary garden chair with the range being extended to include outdoor planters.

more: Concrete 032–033, 076–077, 078–079 Furniture 040–041, 060–061, 076–077, 091, 094–095 Portland Cement 032–033, 076–077, 078–079, 080–081, 122–123

Shifting contexts

The traditional advantage ceramics offers over other materials such as wood, and plastic is its unique marriage with a glaze to provide a permanent bond and finish. The unique approach of this piece combines ceramics with an alternative traditional process.

Inspired by the collection of the ceramics housed in Het Princessehof museum in Leeuwarden, Holland, this Giant Prince vase forms part of a collection where the surface decoration takes on a new form. The pieces subvert the traditional glaze, which is applied to ceramics by introducing a method of ornamentation from another discipline. The embroidered porcelain ⭦ vase creates a new approach to the surface design of this material where the combination of hard and soft materials creates a unique encounter between two materials and processes.

This piece continues the tradition of this internationally known designer, whose work is typified by experimenting with materials and shifting contexts to discover new possibilities for both old and new materials.

Dimensions	70cm x 85cm diameter
Key Features	Receptive to decorative glaze
	Elegant
More	www.jongeriuslab.com

Giant Prince porcelain vase
embroidered with cotton
Designer: Hella Jongerius
Project for: Het Princessehof
Museum , Leeuwarden, Holland
Date: 2000

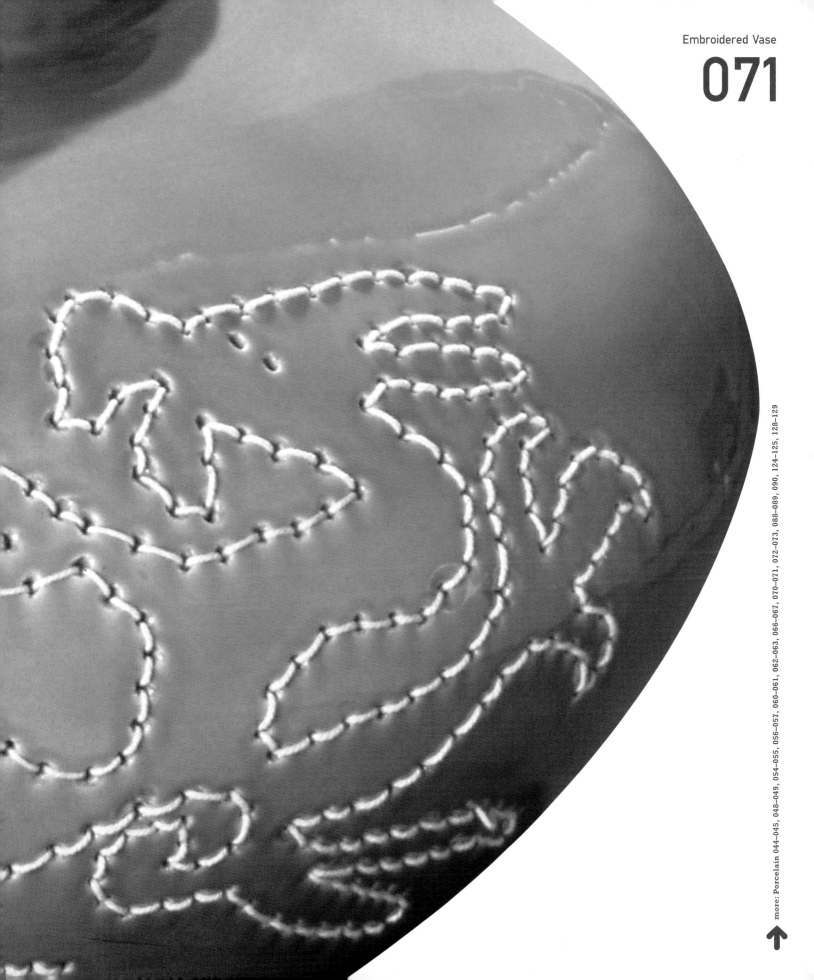

Stony-faced

The brief involves a product where the main function is to be continually pounded, so what kind of material are you going to use? There are obviously hard plastics, which are easy to mould, but there is a chance that, with all that smashing, you will get lots of scratches and particles affecting the taste, and it may not be hard enough. Then you have some type of metal that might also leave a taste and wood just doesn't have the weight, so what are you going to use? Ceramic is the hardest group of materials. Then do you use glass, stone or maybe a grade of porcelain?

The porcelain ⬎ used for these pestle and mortars is no ordinary grade, but a type that is traditionally used in more technical applications like high-voltage electrical insulators. The high strength needed in these applications has been transferred to a more domestic product, which needs to be robust. This is the grade suitable for those heavy pestle and mortars with that cold, white, stony, matt finish — a finish that is made to be ground.

Dimensions	75mm–350mm diameter
Key Features	**High strength**
	Good electrical resistance
	Excellent chemical resistance
	Feels heavy
	Aesthetic
	Scratch resistant
	Stain resistant
More	**www.wade.co.uk**
	www.alliedgroup.co.uk
Typical Applications	**Apart from its use in pestle and mortars, this particular form of porcelain is used mainly for applications where there is high voltage. These include power line insulators to switch gear**

Pestle and mortar
Manufacturer: Wade Ceramics

074

Porous and opaque

Polar Molar is a table-top toothpick holder made in slip-cast ↘, glazed eathernware ↘ by KC Lo ↘.

'Inspiration for my design came from biological illustrations and models while studying 'O' Level Biology. It is designed so that the user can pick up toothpicks in the most hygenic way from the middle of the toothpick (not the ends). This is made possible because of the slot created in the middle of the block,' says KC Lo.

'The name Polar describes its white, glazed body but also plays on the word poles, which also means sticks (in this case the toothpicks). And the word molar is used to symbolise teeth.

'One of the aims of Polar Molar is to allow the owner to put it on the dining table to spark-off interesting conversations among diners at the end of an otherwise boring dinner party!

'The channel requires that it is made in two pieces, which are stuck together to achieve the internal cavity.'

Polar Molar Toothpick Holder
Designer: KC Lo
Prototype: CP Ceramics.
Manufacturer: First production
run by Coral Ceramics
Date: 1999

Dimensions	3.2cm x 8.3cm x 10cm
Key Features	**More prone to chipping than china**
	Less distortion during firing than china or porcelain
	Good for hollow ware
	Generally fired below 1200°C
	Cost effective
More	**www.kclo.co.uk**
	www.cpceramics.com
Typical Applications	**Anything hollow: teapots; vases; figurenes**

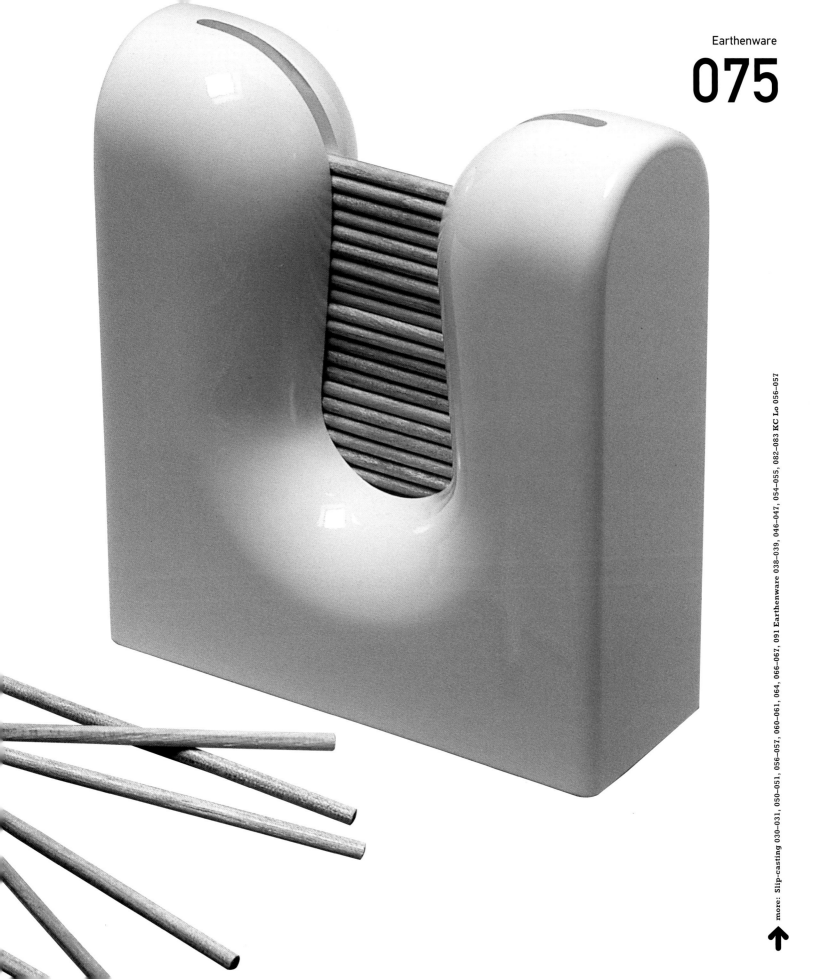

↑ more: **Slip-casting** 030–031, 050–051, 056–057, 060–061, 064, 066–067, 091 **Earthenware** 038–039, 046–047, 054–055, 082–083 **KC** Lo 056–057

076

Using concrete ⬂ to reflect the spiritual and sensual aspects of nature is not something that you often see. The gentle, rural colours and the subtle curves in Maya Lin's collection for Knoll transform the normally cold, grey, biscuit-rough material to a new level of calming bliss.

'Everything I do is very quiet, very subtle. In the furniture ⬂, my designs explore notions of barely perceptible differences, vague asymmetries and off-balance stability,' says Lin.

'The first pieces were the simple stool and coffee table. There is a table, large stools and a baby stool – a family of sculptures, like Goldilocks and the Three Bears. Their elliptical shapes are derived from the pre-Columbian Metate. They have a presence. The slightly curved surface and the subtle concavity create a comfortable seat. The coffee table is slightly convex. The forms are cast in reinforced concrete, which creates a soft, smooth surface like those ancient stone chairs.

'The coffee table hovers just above the ground. It is meant to feel like a part of the land. A swell in the earth, a slight shift of foundation that can barely be perceived. The collection of table and stools want to be outside, in the earth.'

Dimensions	105cm x 73.7cm x 27.5cm,
	67.5cm x 47.5cm x 37.5cm,
	40cm x 30cm x 25cm
Key Features	Excellent strength and toughness
	Easy to mould
	Can be used for low or high volume production
	Each piece can offer a unique surface finish
	Colour can easily be changed
	Relatively low-cost tooling
More	www.knollint.com
Typical Applications	Concrete is one of the most widely used materials. Its hardness and ease of fabrication has made it suitable for applications which range from buildings to furniture and even jewellery

Stones
Designer: Maya Lin
Manufacturer: Knoll
Date: 1998

Spiritual and sensual

078

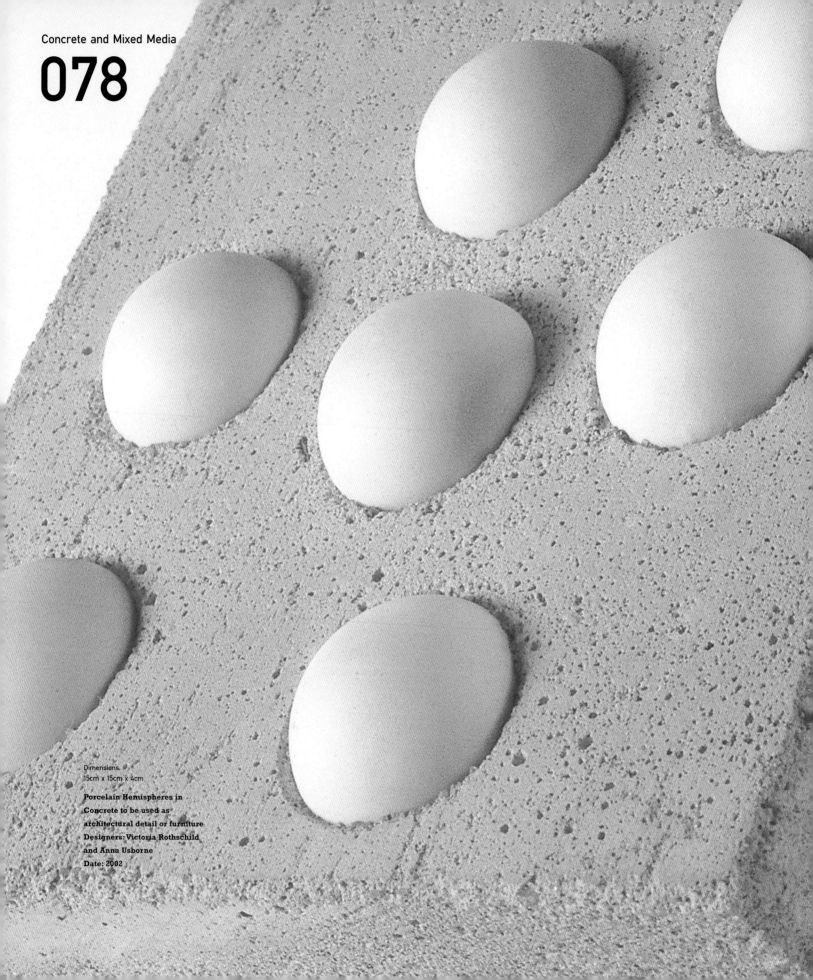

Dimensions.
15cm x 15cm x 4cm

**Porcelain Hemispheres in
Concrete to be used as
architectural detail or furniture
Designers: Victoria Rothschild
and Anna Usborne
Date: 2002**

How do you humanise the urban and rough image of concrete ↘? This was the starting point for this project by Victoria Rothschild and Anna Usborne. While still students at the Royal College of Art in London, they produced this range of experiments for a competition sponsored by the British cement association. Using a mixture ↘ of different ceramic materials like terracotta ↘, glass and porcelain ↘ they have created an ensemble of ideas pushing the boundaries and cultural definition of concrete.

All the pieces were shaped and cut using a diamond saw. For the polishing and smoothing, a flatbed grinder was used. The cement used was either Snowcrete or White Ciment Fondu Secar 71, which is a refractory ceramic. The grey cement was Portland cement ↘. The mix was three parts aggregate to one part cement.

Key Features	Exceptional compression strength
	Can be used for low- or high-volume production
	A range of aggregates can be used for a variety of effects
	Colours can be changed easily
	Fairly low-cost tooling
	High labour cost
More	www.bca.org.uk/
	www.concrete-info.com
Typical Applications	The majority of concrete used is for building applications. However, through various artists and designers exploring new possibilities for the material, new applications have been discovered which include: jewellery, furniture, kitchen work surfaces and tableware

Gritty surface

Dimensions
30cm x 20cm x 8 cm

Decorative wall feature
Designers: Victoria Rothschild
and Anna Usborne
Date: 2002

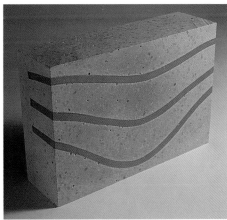

Dimensions
30cm x 20cm x 8cm

Terracotta and concrete block
Designers: Victoria Rothschild
and Anna Usborne
Date: 2002

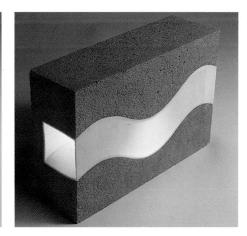

Dimensions
15cm x 10cm x 6cm

Porcelain wavy light strip
in concrete
Designers: Victoria Rothschild
and Anna Usborne
Date: 2002

080

Surprise surface

This is one of the superior types of cements. Available in rich chocolate and dark grey tones or even a highly polished white. This cement offers the designer far more potential than Portland cement ↘ to experiment with the more decorative and aesthetic qualities of this abundant material.

Compared to Portland cement, which is based on silica and limestone, Ciment Fondu has a range of advantages: it has the ability to form far more complex shapes and to withstand temperatures up to 2000°C compared with 500°C for Portland cement; it is also much more durable.

Kelvin J. Birk is a gold and silver designer who enjoys exploring the unexpected encounter between the precious and the utility. The specific use of Ciment Fondu provides the freedom to experiment with a range of finishes and colourings.

Round Gilded Bowl
Designer: Kelvin J. Birk
Date: 1999

Dimensions	30cm diameter
Key Features	**Ability to form complex shapes**
	Quick-drying but long working time
	Fast mould turnaround
	Achieves in 24 hours the strength that takes Portland cement 28 days
	Same working time
	Superior surface finish
	Good corosion resistance
More	**www.lcainc.com**
Typical Applications	**Quick-drying flooring where paint or polymer coverings need to be set over the top. It is also the basis for fast-set tile adhesive and floor-levelling compounds. Also as a medium for artists and craftsmen and high temperature applications in the steel industry**

more: Portland Cement 032–033, 068–069, 076–077, 078–079, 122–123

Dimensions	11cm x 48cm diameter, 14cm x 61cm diameter
Key Features	Generally fired below 1200°C
	Less distortion during firing than porcelain or chi
	Versatile range of processes available
	Cost-effective
	More prone to chipping than china
	Not as dense strong as stoneware
More	www.satyendra-pakhale.com
Typical Applications	Used in all product areas from large sanitary ware to mugs and plates

Workhorse

With any industry, there are always materials which, through their balance of physical and chemical properties and cost, become widely used. They may not have any great distinguishing properties or anything extraordinary about them they just offer the right balance of characteristics at the right price. In the area of advanced ceramics, alumina ⬎ is this type of material, but in the area of traditional ceramics, earthenware ⬎ is the workhorse. It is used in many ceramic products from small items of tableware to large pieces of sanitary ware.

Earthenware is a porous, opaque ceramic and, unlike the vitreous and translucent porcelain or china, needs to be glazed to be watertight and hold liquid. One of the common tests used to distinguish this material is to put your tongue on the unglazed underside of a piece to test its absorbency. Although it is not as strong or as dense as china or porcelain and is prone to chipping, it has the advantage of less distortion in lower firing temperatures and is thus more stable during processing.

**Kalpa-Ceramic Vase and Bowl in
One Object
Designer: Satyendra Pakhalé
Designed: 2002**

more: Alumina 014–015, 018–019, 029, 036, 048–049, 052–053, 070–071, 098–099, 118–119 Earthenware 038–039, 046–047, 054–055
Satyendra Pakhalé 094–095

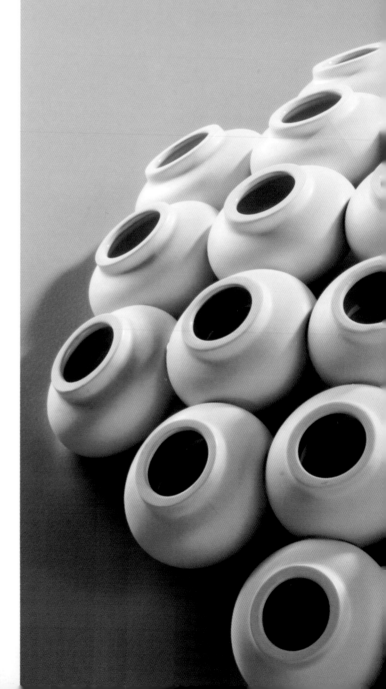

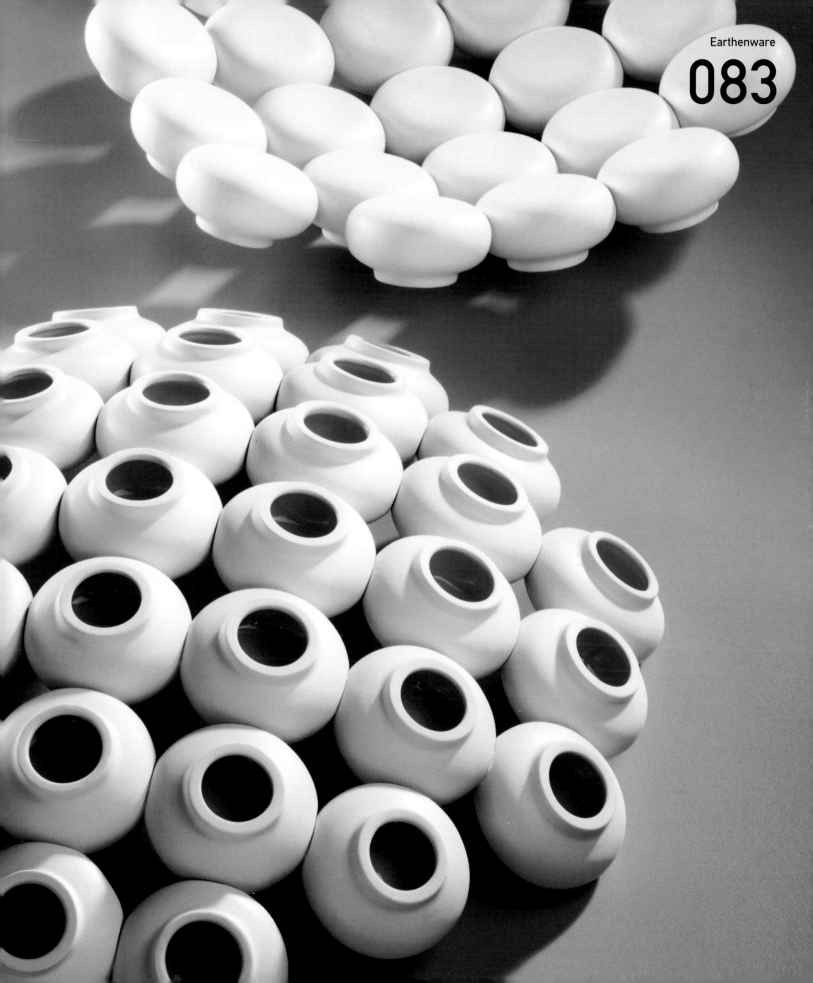

085 Production

086

Cost-effective, high volume

From prototypes to production runs, UK-based company Ceramic-Substrates & Components Ltd offers the potential for milling, extrusion, pressing ⬐ and cutting in a variety of ceramic substrates. However, dry-powder compaction is the most economical way of mass producing ceramic components.

Normally you have to make big investments in tooling to achieve a low unit cost for mass production. However, with relatively low set up, this production method can produce anything from 1,000 to 20,000 units per hour, depending on the component size.

Raw materials in the form of rocks and powders arrive at the factory and are compounded into an assortment of components. These mined mineral powders are blended together to form certain recipes, giving a range of standard materials. These are mixed with binders from which granules are produced. It is then the granules which are compacted into the final components. Dry-powder compaction involves two parts of a mould coming together without any heat and compressing ⬐ the powder into a component. Any additional machining is done before the component is fired. The process is simple to maintain and offers mass-production without massive tooling costs.

Dimensions	7.4cm diameter ring
Key Features	Cost-effective tooling
	Fast
	Simple process to control and maintain
	Cost-effective machining
	Fine tolerances
	Range of materials can be used
	Scale of production from batch to high-volume
More	www.ceramic-substrates.co.uk
	www.advancedceramicmaterials.com
	www.metall-chemie.com
Typical Applications	Suitable for any solid or machined components that require a high degree of accuracy. Typically products are for industrial applications and can include lamp caps and industrial ceramics for thermal and electrical insulation

The three stages of production of an engineering component made from HF300 Streatite: powder, cut ring, finished component
Manufacturer: Advanced Ceramic Substrates

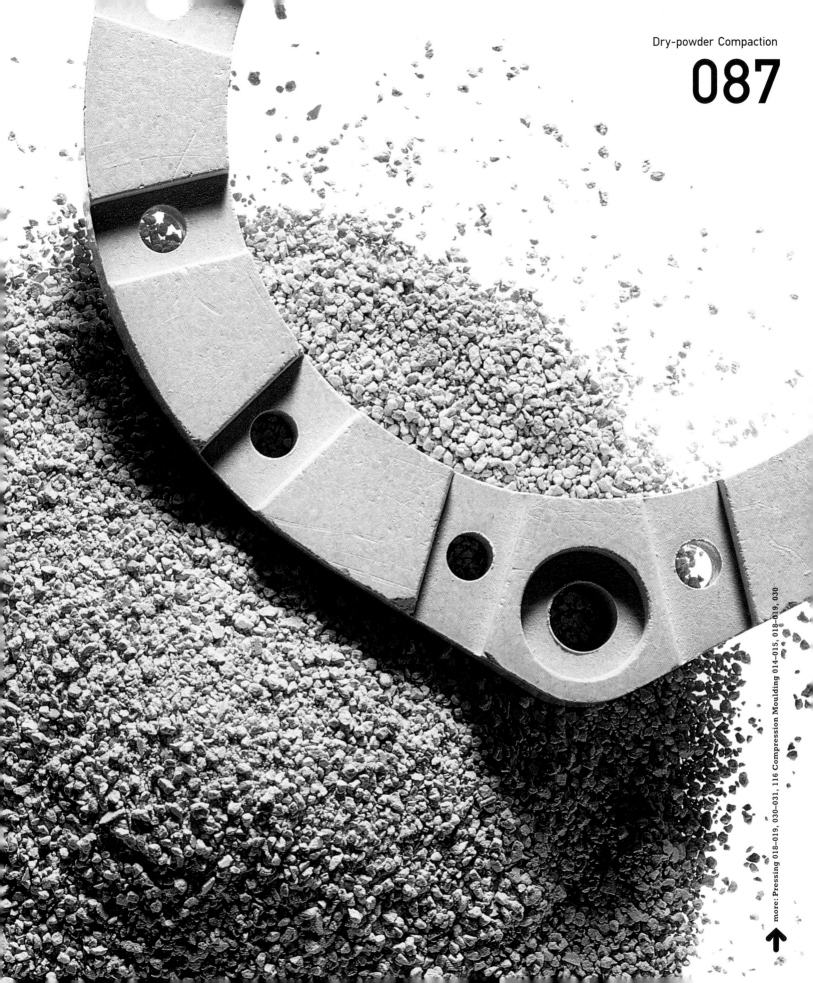

more: **Pressing** 018–019, 030–031, 116 Compression Moulding 014–015, 018–019, 030

Micro sculpture

We are becoming increasingly aware of the possibilities of enhancing and replacing various parts of our bodies. This blend of porcelain ⬎ allows dental ⬎ ceramicists to make exact dental reproductions of teeth. With their hardness, durability and inertness ⬎, ceramics are the perfect material for bone replacement ⬎ in our mouths. In this context, it is not just the physical properties that are useful but also the aesthetic characteristics of a material that can be tinted and easily shaped to take on any form and shade of whiteness.

Starting from casts and photographs of existing teeth taken by your dentist, a dental laboratory can build a virtually identical dental crown or inlay. Using a starchy, porcelain paste, which is built over a metal core, the tooth is built up over several stages of firing using a brush or sculpting knife. The process requires a high degree of skill to form the tooth and match it to existing teeth. When finished, a ceramic tooth will probably last longer then the original it replaces.

Dimensions	**Individually constructed for each patient**
Key Features	**Easy to handle**
	High degree of skill is needed
	Fine-grained porcelain
	A range of grades available to suit different colourings
More	**www.schottlander.co.uk**
Typical Applications	**This method of building up layers of porcelain with a paste is most suited to small parts where each component is a different shape**

The process of building up
a crown using Matchmaker
bonded porcelain
Manufacturer: Scottlander

Surface detail

These porcelain formers are the hidden jewels of production, the unseen tools that are used to make these most banal and common products. To see these ceramic components is to open up the secrets of the production of everyday rubber products like balloons, surgical and household gloves and condoms. From the hands that look like spare body parts to balloon formers, these are the kind of things you might have on a game show where you have to name that object or invent uses for them.

They also demonstrate a good use for the ever-popular porcelain ⬃. As a material, it is highly suited to this type of industrial production its strength, chemical inertness, hardness and its ability not to be affected by temperature changes makes it suitable for dipping into hot rubber. As the formers are cost-effective to make, the opportunity is there for designers to explore this simple production process.

**Porcelain formers for dip-moulded rubber gloves
Manufacturer: Wade ceramics**

Key Features	Simple production method
	Low-cost tooling
	Small- or high-volume production runs
	Ideal for smooth shapes
	Chemically inert tooling
	Limited to rubber products
More	www.wade.co.uk
Typical Applications	This type of former is also used to make a diverse range of products including formers for surgical gloves, balloons, bladders, and baby bottle teats

Dimensions	39cm x 36cm x 55cm
Key Features	**Can offer versatile with production volumes**
	Ideal for producing hollow-ware
	Limited control over wall thickness
	Efficient use of material
	Labour intensive
	Limited dimensional control
	Slow production rate
More	**www.ideal-standard.co.uk**
Typical Applications	**Slip-casting is used to make hollow one-off and tabletop objects like teapots, vases, and figurines to the high volumes of sanitary ware**

The bathroom is a Mecca for domestic ceramics. Glass mirrors, sinks, toilets, baths, porcelain enamelling ↘ on baths, wall and floor tiles ↘, and so on. Their hard, glassy, non-porous surface makes them easy to clean and resistant to stain. But some of the biggest ceramic products you will find anywhere are the toilet and sink.

The principles for producing sanitary ware are based on those of slip-casting ↘. There are various forms of slip-casting which are dependent on the type and scale of product. The process is used for making forms that need to have cavities or are hollow. To slip-cast a piece, ceramic particles held in water are poured into a porous mould. In many cases, the mould is made of plaster, which draws out the water from the wet slip and leaves a ceramic slip on the inner surface of the mould. The mould is inverted and the excess ceramic is poured out.

For the production of the large pieces of sanitary ware, a form of slip-casting known as vacuum pressing is used. This involves pumping the slip (watery clay) into a porous mould. Under this pressure, the water seeps out from naturally occurring capillary tubes in the mould. Once dried, the form is taken out of the mould and any imperfections cleaned off the product is dried in fast dryers and sprayed with a glaze before firing. As with any fired piece moulds need to made to take account of a reduction of size once the product has been fired.

Alto Toilet
Designer: Ideal Standard Studio
Manufacturer: Ideal Standard

Sanitary

092

Jiggering and jollying are two very similar industrial processes that are generally used to make round, flat and hollow tableware. Because they both rely on rotation, they can be seen as a kind of throwing. Compared to slip-casting, where the detail on the inside wall of a piece is totally dependent on the outside form, these two processes allow for total control over both the inside and outside profiles.

Stages of jollying

Jollying is used to make deep hollow-ware and begins with clay slugs being extruded and cut into disks, which are used to form liners. Liners are like clay cups that are formed to be close in shape to the final piece. These liners are placed inside the cup mould, which is fitted to a rotating spindle on the jollying wheel. This is where the similarity to hand-throwing comes in: On this rotating spindle, the clay is drawn up the inside of the mould forming the wall. A profiled head is then brought down into the cup to scrape away the clay and form the finished and precise inside profile.

Stages of jiggering

Jiggering is a very similar process to jollying but is used to form flat rather than deep hollow-ware. It works in an inside-out way to jollying, where the shaped profile is cutting the outside surface rather than the inside.

Again, a slug of clay is formed and placed over a rotating mould, known as a spreader. Here it is formed into an even thickness by a flat profile. This thick pancake, or 'bat', is removed and placed onto the plate mould. This mould forms the inside shape of the plate. The whole thing rotates and a profile is brought down to scrape away the external side of the clay and form a precise uniform outside shape.

Key Features	Allows complete control of the thickness and shape of sections
	Limited to symmetrical parts
	Can be inaccurate due to shrinkage during firing
	Cost effective compared to slip-casting
	Less prone to distortion than cast pots
More	www.wade.co.uk
Typical Applications	Basic jollying is used to make small pots, cups and bowls and deep, open-ended vessels. Jiggering is used to make shallow items like plates, saucers and shallow bowls

Standard issue
tea cup and saucer

Cups and saucers

more: **Plates 038–039, 046–047 Mugs 050–051**

Industrial shapes

Apart from bathroom sanitary ware, examples of ceramics used for furniture ⊠ are fairly limited. However, the highly distinctive forms produced by designer Satyendra Pakhalé ⊠ bring a unique visual language to this area of design.

The references to mass-produced industrial shapes are combined with the ancient process of turning clay on a wheel ⊠ to produce a range of large-scale furniture pieces.

'The choice of clay was critical in deciding which clay mixture would be elastic enough to throw while keeping the desired strength. Equal drying of the different wall-thickness of the thrown clay parts and firing it without cracks was a challenge,' says Pakhalé.

The time it takes a piece to dry before firing is related to several criteria, the clay body (mixture), its scale, complexity and thickness. A consistent drying time is essential and for this complex piece it took two to three weeks. Initially, there were problems of cracking when the chair was fired as a complete piece, the design had to be adapted resulting in the front and back parts being produced separately. These were joined together after firing with a two-part polyurethane glue.

Initially produced using a craft process, the chair has since been developed to take advantage of industrial production. It is now produced using pressure-cast moulds similar to those used in the sanitary ware industry.

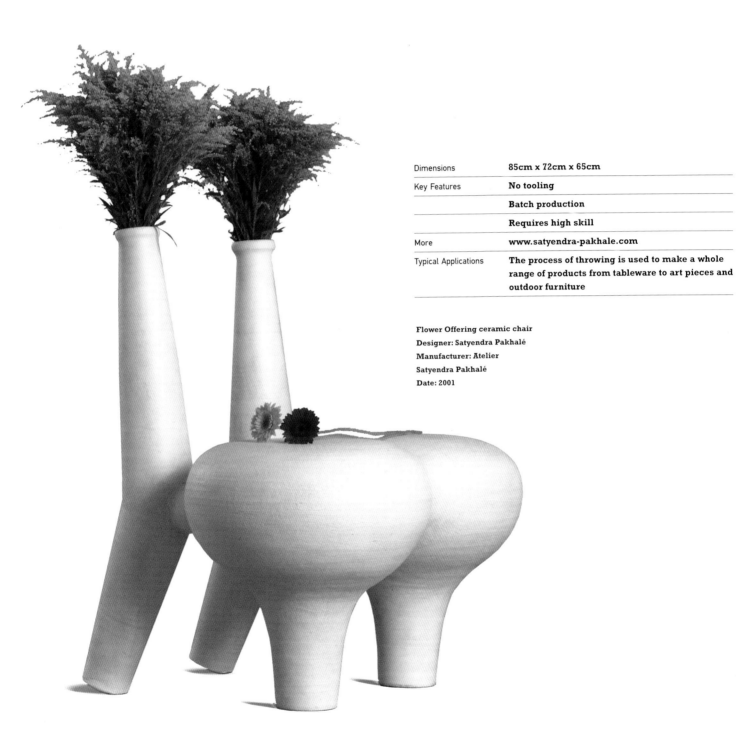

Dimensions	85cm x 72cm x 65cm
Key Features	**No tooling**
	Batch production
	Requires high skill
More	**www.satyendra-pakhale.com**
Typical Applications	**The process of throwing is used to make a whole range of products from tableware to art pieces and outdoor furniture**

Flower Offering ceramic chair
Designer: Satyendra Pakhalé
Manufacturer: Atelier
Satyendra Pakhalé
Date: 2001

more: Furniture 040–041, 060–061, 068–069, 076–079, 091 Sathendra Pakhalé 082–083

100 million pieces

Key Features	Designed for mass production and complex shapes
	Low additive and labour cost keep production cost down
	Short cycle time
	Low labour costs
More	www.ceram.com
	www.royal-doulton.com
	www.epsrc.ac.uk
Typical Applications	The process of injection moulding ceramics opens up a whole new set of possibilities for producing small- and medium-sized products in ceramics. There is no limit to the types of product areas where this technology could be applied

Old Country Roses teacup
Designer: Harold Holdcroft
Funded by: Ceram, Royal
Doulton and the Engineering
and Physical Sciences
Research Council

Injection moulding ⬎ is a standard method of production within the plastics industry. Traditionally cups and handles were made separately, then joined, but this method is labour-intensive and slow, adding to the unit costs of the product. Yet injection moulding has been under-utilised within ceramics because of the costly binders used which can cause problems when firing small pieces. These issues are addressed by using viscous plastic processing (VPP) technology, which reduces the amount of binder. Most of the development work within this area has been based around bone china, but the advancement of injection moulding in ceramics opens the design brief to a whole new set of commercial and design possibilities.

Funded jointly by Ceram, Royal Doulton and the Engineering and Physical Sciences Research Council, these bone china cups are the result of exploring the use of injection moulding as a cost-effective, mass-production process. Having sold over 100 million since 1962, this is the most successful ceramic range of all time.

Digital tableware

Making prototypes used to mean employing a model maker to make your design by hand. Today many industries are exploiting the various forms of rapid prototyping to produce these models. These CAD-driven machines provide designers with the ability to produce samples and prototypes faster and more cost effectively than traditional methods.

Some of the most common involve polymer resins. However some manufacturers believe that plaster can give a much better representation of a final ceramic design than these resins, with a look and feel more akin to a biscuit-fired ceramic. Manufacturers like Royal Doulton use a three axis milling machine driven by CAD programme to carve out wet plaster.

Initially a block of plaster is cast which is allowed to dry for about 30 minutes. At this stage, the plaster is hard but still wet and is ready to be cut. By cutting the plaster in this wet state the amount of dry dust that would be produced if it were dry is greatly reduced. This means that apart from creating a cleaner working environment the wearing on the tool is also reduced.

The advantage of CAD-driven models is not only restricted to faster turnaround times for mock-ups; the use of computer modelling allows for a far greater range of complex surface patterns to be created, which otherwise would have been difficult using traditional methods.

Touch range
Manufacturer: Royal Doulton

Key Features	**Fast turnaround of samples**
	Allows for fine and complicated detailing
	Expands scope for design
	The fast turnaround allows for more concepts to be considered
	The plaster more closely resembles the final material than a resin version
More	**www.royal-doulton.com**
	www.the-hothouse.com
Typical Applications	**This process can be used on any product or shapes, which can be generated by computer. The only size restriction is that of the machine but otherwise any type of product can be prototyped. Most products are tableware**

Line drawing

From slots and holes to complicated patterns and shapes; from drilling to scribing; flat sheets of ceramics can be cut to any shape you can draw with a pencil. Laser-cutting is a well-known process for cutting intricate shapes from flat materials. Used for cutting wood, metal and glass, it offers designers the opportunity to create decoration or intricate individual components from a flat sheet.

But the chance to create complex patterns in ceramic is not as widely exploited or as well known as it is for other materials. The process offers flexibility in terms of production, speed and opportunity to create details with very high tolerances. Starting from a CAD file and with no tooling, the process is cost-effective for one-offs or batch production. But the really interesting thing with this process is that it creates components that have a totally different quality to other materials. These samples of laser-cut alumina ⬎ are reminiscent of rigid, brittle pieces of stiff, cold paper. With a scratchy, almost chalky surface and a soft translucency, they suggest applications which are not just for electronics.

Dimensions	100 microns–2mm
	Tile sizes vary depending on thickness and availability.
Key Features	Can be cut directly from a CAD file
	No tooling
	Flexible production process
	Suitable for low- or high-production volumes
	Tolerance can be controlled to 20 microns
	Can be used for a variety of materials
More	www.lasercutting.co.uk
Typical Applications	Due to the cost of the ceramic substrate, laser-cut ceramics are generally used on a small scale with applications in the microelectronic industry as a basis for printed circuitry

Range of laser-cut samples produced from alumina substrates
Manufacturer: Laser Cutting UK

Cost-efficient

So you've designed that new ashtray or the toothpick holder for a client who owns a chain of bars and restaurants who has decided he needs 500 units rather than the 5000 originally ordered. What do you do? You need to find another supplier because the agent who represents the manufacturers won't return your call for less than 2500 units.

There are many companies whose business is to take up orders from designers dealing in niche products based on medium-scale production runs. Due to its abundant source of good clay and coal, Stoke-on-Trent is the centre of ceramic production in the UK. The area is a microcosm of the whole ceramics industry and is one of the major producers of ceramic products in the world. It offers a one-stop range of products for a whole list of packaging, promotional, domestic and industrial products from ornamental and functional ceramics such as door handles, bathroom fittings and accessories, aromatherapy bowls and exterior plaques to bespoke artifacts. Manufacturers in the area use just about every ceramic production process available including slip-casting solid or hollow, high-pressure casting used for bar ware, extruding, wet-pressing, ram-pressing, turning and powder-pressing.

Dimensions	45.5cm x 6cm diameter
Key Features	Low- or high-volume production runs
	Can be used for a range of materials
	Can have low tooling costs
More	www.wades.co.uk
	www.johnson-tiles.com
	www.matthey.com
	www.churchillchia.com
Typical Applications	Turning is used to make symmetrical products and components including: door handles; pestle handles; and electrical insulators

Porcelain rolling pin with
beech wood handles
Manufacturer: Wade Ceramics

Viscous plastic processing (VPP) is a process for forming ceramics that have been eliminated of microstructural defects or flaws. This gives the material improved characteristics.

The toughness of ceramics is reduced by microscopic defects within the material. These tiny faults mean the material's ability to plastically deform is reduced. So if you put the material under tension, it is likely to break. By removing these small pockets of air, cracks and amassing of ceramic lumps, the ceramic is eliminated of its flaws.

This means that the type of products, the types of production methods used and a whole range of simple and complex shapes can be produced in a variety of materials, which would have been difficult or impossible before. (Polymer forming techniques: Ceramic mixed with viscous polymer solution).

Conventional plastic-forming techniques can be used to form complex thin, flat sheet extrusions and mouldings. The enhanced properties it offers ceramics allows for objects to be produced with thinner wall sections and reduced weight, without compromising on performance.

Conventional or novel plastic-forming processes may be used to shape the ceramic paste and the green material is easily machined, offering economies for difficult shapes. Viscous plastic processing can result in products of much greater flexural strength than those achieved by powder-pressing, for example.

Dependent upon the grain size of the powder, a superior surface finish is obtained. VPP provides further advantages by improving other flaw-controlled properties such as translucency, electrical resistivity and dielectric loss.

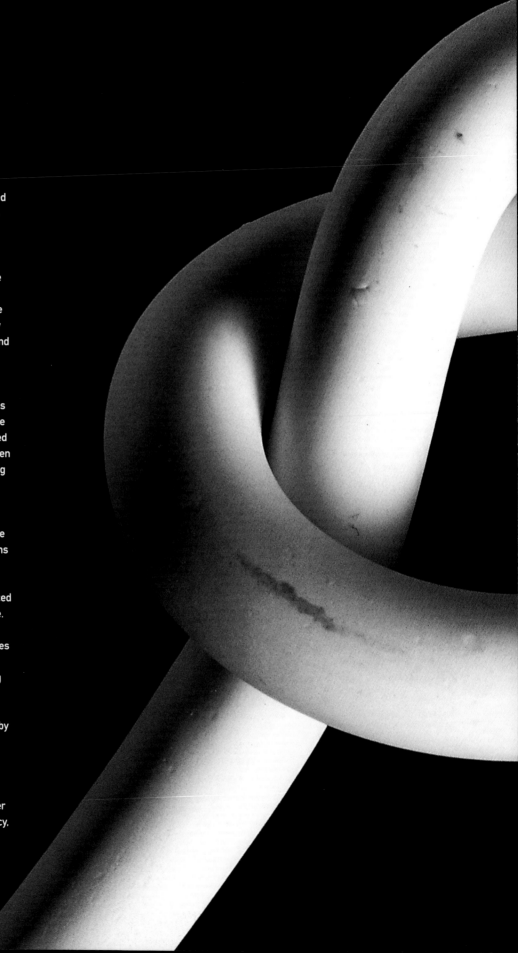

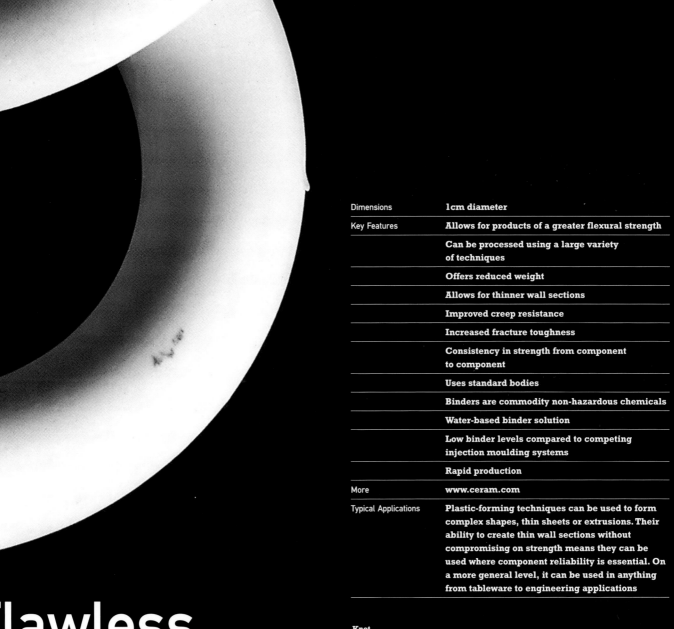

Dimensions	**1cm diameter**
Key Features	**Allows for products of a greater flexural strength**
	Can be processed using a large variety of techniques
	Offers reduced weight
	Allows for thinner wall sections
	Improved creep resistance
	Increased fracture toughness
	Consistency in strength from component to component
	Uses standard bodies
	Binders are commodity non-hazardous chemicals
	Water-based binder solution
	Low binder levels compared to competing injection moulding systems
	Rapid production
More	**www.ceram.com**
Typical Applications	**Plastic-forming techniques can be used to form complex shapes, thin sheets or extrusions. Their ability to create thin wall sections without compromising on strength means they can be used where component reliability is essential. On a more general level, it can be used in anything from tableware to engineering applications**

Flawless

Knot
Manufacturer: Ceram

103 Semi-formed

Compressive strength

By brick clay I mean the reddish, dusty, gritty and sand-rough material that is the most ancient of artificial building materials. There are thousands of alternative shapes and functions in which they are available and they give the most widely used example of the compression strength ⊻ of ceramics.

There are two widely used types of brick clays, which manifest themselves in two colours: the first consists of non-chalky clays, sand feldspar minerals and iron compounds which, after firing, become salmon coloured; the second comprises a more limey clay which contains 40 per cent calcium carbonate, that are yellow when fired. However, the precise type and colour of clay is dependent on the area they are dug from, the method of firing and the type of kiln used.

There are many companies who mass-produce standard bricks in an assortment of standard shapes and sizes. The distinguishing feature of H.G. Matthews is their ability to produce individual and specific architectural building products. Their hand-made bricks are considered to be some of finest bricks available, their quality based on appearance, character and range of colours, including orange, browns, light and dark purples. With a large percentage of their bricks hand-made, they offer a flexible production base from one-offs to mass-production.

Sample of brick clay
Manufacturer: H.G. Matthews

Key Features	Excellent uniformity of strength
	Excellent crushing strength
	Distinctive surface
	Can be formed with a range of processes
	Weather-resistant
More	www.hgmatthews.com
	www.ibstock.co.uk
	www.imerys-structure.com
	www.Yorkhandmade.co.uk
Typical Applications	Walls; paving; date bricks; friezes; plinths; bricks; and architectural special mouldings

more: Compression Strength 014–015, 028, 032–033

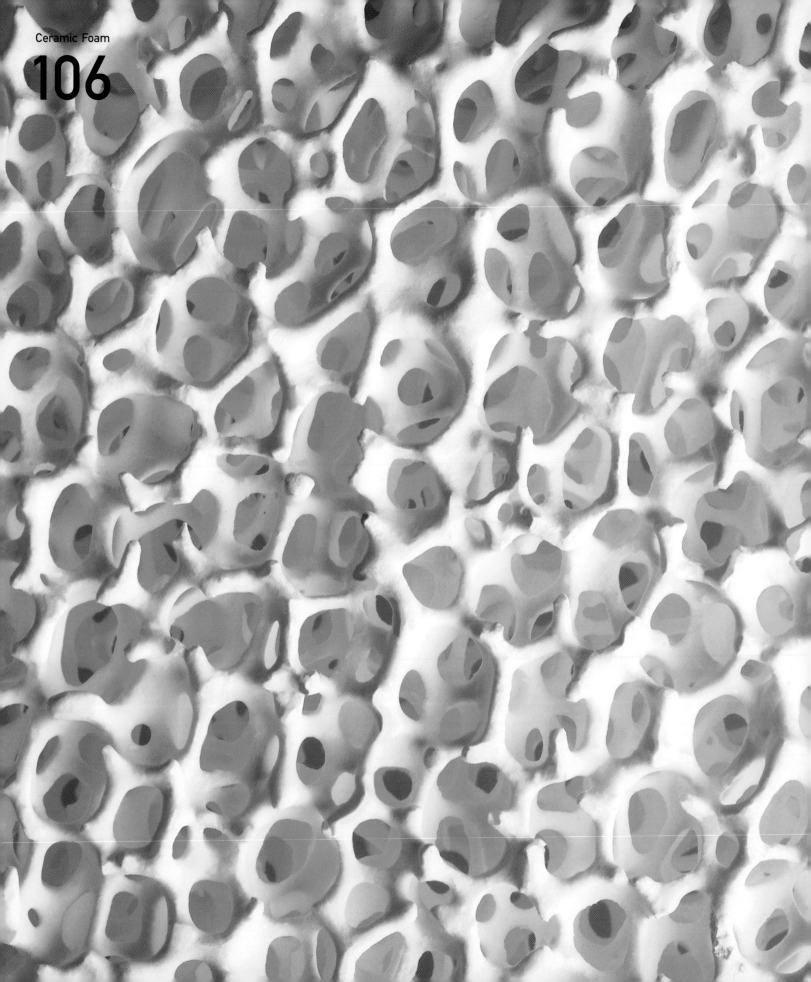

Spongy

By semi-finished materials, I am referring to those off-the-shelf products where the raw material has been formed into a substance that can be machined and processed into a new form: like ceramic paper ⬎, yarn ⬎ or spheres ⬎.

Usually produced for engineering and industrial applications, they have the opportunity to find their way into more domestic products. These examples are always the most intriguing because they take properties from one material and combine them with those of another.

Ceramics are known for their ability to stand up to extreme temperatures. This sample of Selee® ceramic foam was originally developed for filtering, treating and cleaning hot molten aluminium alloys. But it is the combination of the visual softness and open-cell structure of foam and a hard material-like ceramic that is one of its most interesting features. The material is made by coating reticulated (open-cell) polyurethane foam in a ceramic slurry. Once the water has been removed from the slurry, a thin coating is left which is then fired at a high temperature burning off the polyurethane foam.

This hybrid of material qualities offers designers possibilities to create new products from this highly decorative, hard, light and unique structure.

**Close-up view of the Selee®
ceramic foam structure
Manufacturer: Selee Corp, USA**

Dimensions	**Available in a large range of standard sizes, thicknesses and shapes and in foam sizes of 25.4 to 177.8 pores per cm**
Key Features	**Available in a large variety of compositions**
	100% open cell
	Low fluid-flow resistance
	Very good thermal shock resistance
	Low absorption of heat
Typical Applications	**The nature of its open structure, with large areas of air, has an application for radiation shields. The foam is also used for kiln furniture and, due to its large surface area, as a catalyst carrier**

more: Ceramic Paper 108–109 Ceramic Yarn 110–111, 112–113 Ceramic Spheres 114–115, 138–1390

108

This is a super material! If you visit the website of its producers, the American company 3M™, you will find an image of someone pointing a very hot blow torch towards one side of a piece of ceramic paper. On the other side is an ice cream. The only thing that stops the ice cream from melting is this thin piece of flame-stopping ceramic paper.

This is an incredible product. Covered with small dots, which hold the fibres together, the material is paper-thin and feels like a soft woven fibrous sheet. What makes it even more amazing is that it is also translucent, so although you can see through it, it won't allow a flame to penetrate it. The fact that this is paper means it can be sandwiched between layers of secondary materials or applied to existing surfaces which might need fire protection.

This sample by 3M™ is part of the Nextel™ family of ceramic fibres. One of its major applications is as a thermal barrier in transport, where it is designed to perform at a continuous temperatures ⊿ of 1204°C. This is not the only material that stops flames but its has the key advantage of being thin, flexible ⊿ and lightweight.

Dimensions	**Nextel™ ceramic paper is available in a range of thicknesses and sheet sizes**
Key Features	**Easy to cut, wrap or form**
	High heat resistance
	Good thermal stability
	Low thermal conductivity
	High tensile strength
	Non-irritating
	Lightweight
	Will not melt or shrink when exposed to fire
More	**www.mmm.com/ceramics**
Typical Applications	**This material has uses within a range of industrial applications, including: aerospace, where it is used as a flame barrier to protect passengers on civil aircraft; and polymer composites**

**Sample of Nextel™ Flame
Stopping Paper
Manufacturer: 3M™**

Fireproof

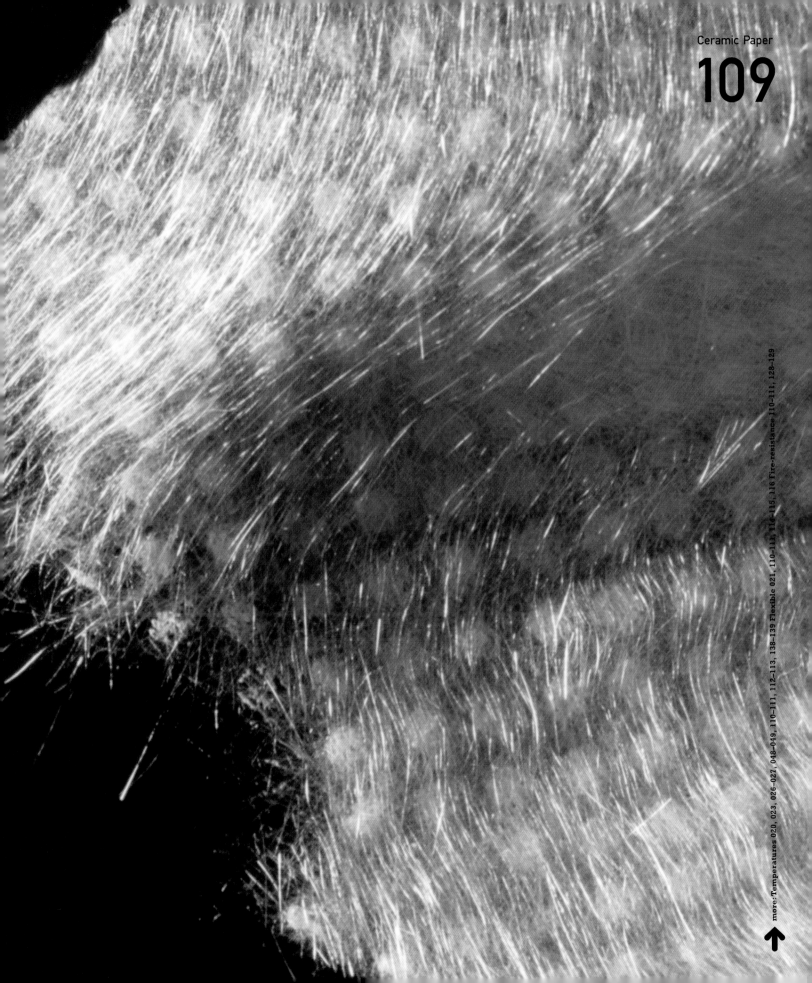

One of the major industries in which ceramics are used widely is within refractory applications. Their unique heat and flame resistance ⬎ puts them on top of the material tree when it comes to these thermal properties. However, these are products which take on a different form to the solid brick variety and allow for this heat ⬎ advantage to be used in a range of applications outside of the industrial ovens.

This is a product that provides the opportunity for flexibility ⬎ in a flame barrier. There are many applications where fire safety is an issue, ranging from aerospace, outerspace and automotive to industrial.

These fibres are continuous and strong which means they can be used without the need for additional support. They can be made into a range of products including paper ⬎, yarns, fabrics ⬎, tapes and sewing thread and also in a range of grades for both non-structural and load-bearing applications. Considering this material is used to deflect heat from jet engines, you know this is serious stuff.

Flexible flame barrier

Dimansions	**91cm–147 cm wide. Special order items are available to meet the needs of the application**
Key Features	**High temperature applications up to 1371°C**
	Flexible
	Good resistance to abrasion
	Low elongation at operating temperatures
	Low shrinkage at operating temperatures
	Good chemical resistance
	Low thermal conductivity
	Thermal shock resistance
	Low porosity
More	**www.mmm.com/ceramics**
Typical Applications	**One of the big markets for these materials is in the area of fire safety, including: suits for racing car drivers; soft panels for the cockpits of Formula 1 cars; floor mats for cockpits; industrial applications for furnace curtains; structural reinforcement; sewn refractory parts and shapes; fire barriers and insulation shields**

Nextel™ ceramic textiles
Manufacturer: 3M™

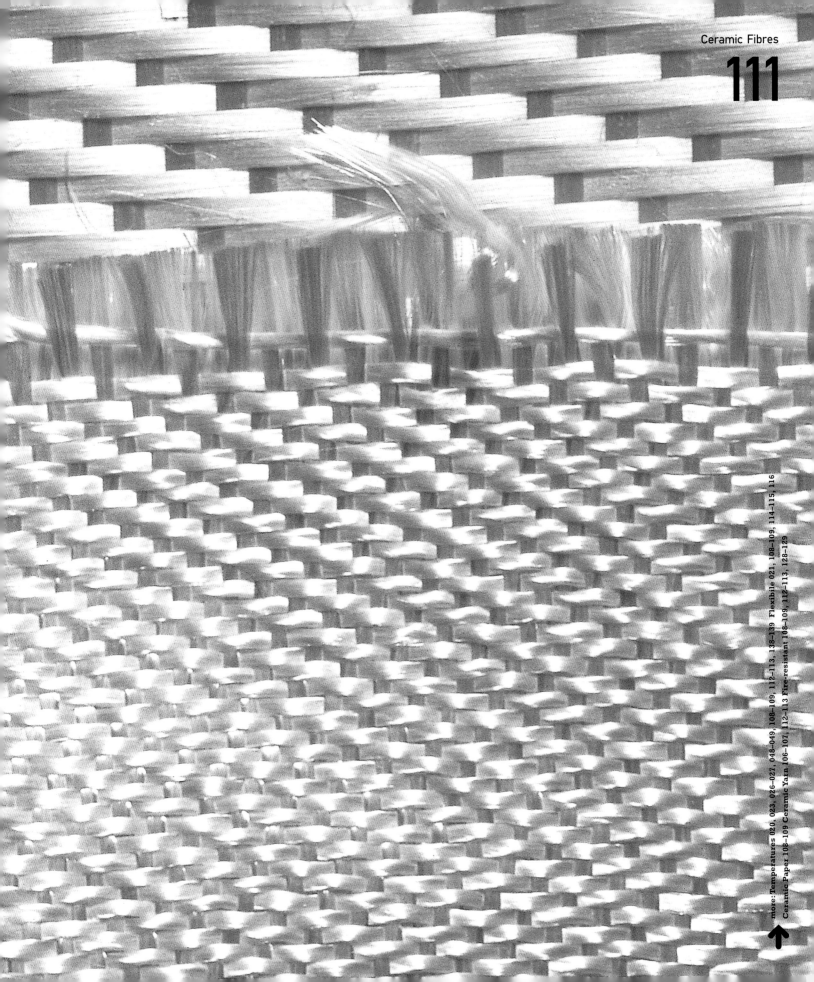

Wearable

There are all sorts of thermal barriers, from paper ↘ and fibres ↘ to solid slabs of ceramics. But this is one of the most unlikely heat resistors from a material that is normally known for being hard and brittle. This is not a material that feels fibrous like ceramic fibres might. Neither is it the kind of shiny material that you might find on a fire suit. This material looks and feels like any other soft piece of fabric, but has the ability to absorb UV rays and keep you cool in the heat of the sun.

Made from polyester, combined with ceramics, this thermo-reflecting yarn provides the answer to all those summer sun issues. Sunfit is a high-tech material that can be used with traditional fibres to make clothes that act as a thermal barrier to the sun, allowing the body inside to breathe and keep cool. Promoted as a fabric for performance sportswear, the product is also being promoted for more general usage on the grounds of safety from the danger of overexposure to the sun. Plus, now when the sun comes out and the temperature ↘ rises, there'll be no more sticky or clingy t-shirts.

Key Features	Good at working with natural fibres
	Absorbs UV rays
	Keeps the body cool
	Feels like a normal fabric
	Can be manufactured like most fabrics
More	www.aquafil.com
	www.aquafiltextileyarns.com
	www.gruppobonazzi.com
Typical Applications	Sunfit can be used for most swimwear, sportswear and leisurewear garments

Sunfit textile yarns
Manufacturer: Aquafil

more: Ceramic Paper 108–109 Ceramic Fibres 110–111 Temperatures 020, 023, 026–027, 048–049, 108–109, 138–139 Fire-resistant 108–109, 110–111, 128–129

Micro ceramics

Materials serve as many discreet functions in their own rights as they do for the objects which they form. Like ingredients added to food recipes, they perform particular functions designed to enhance the performance of their host. Available in a range of microscopic sizes, this application for ceramic spheres ⌄ has offered a wide range of industries increased performance.

The American company 3M™ produce two groups of ceramic spheres: Z-Light Spheres™ and Zeeospheres™. Without a microscope, these spheres appear as a fine powder and are used to fulfil a wide range of applications in different industries. These semi-transparent, white-coloured, fine particles can offer increased hardness and abrasion resistance when mixed in to a variety of coatings. The chemical inertness ⌄ of ceramics is also an excellent feature for providing an inert protective barrier within a paint or coating, offering protection from various types of chemicals, weathering and corrosion. The spherical shape also helps material flow for plastic-moulding applications.

Depending what an application requires, these strong, hard, inert and hollow spheres offer the designer the opportunity to increase the performance of a range of products or materials.

W610 Zeeospheres™
Manufacturer: 3M

Dimensions	Three white grades: 12, 23–25 and 42–45 microns
Key Features	Good hardness
	Excellent abrasion resistance
	Chemically inert
	Low density
	Available in a range of particle sizes
More	www.3m.com/microspheres/index.html
Typical Applications	The various features of ceramics offer benefits for a range of applications. Their hollow form can be used to help form a thermal barrier in various materials. Their hardness is used to increase wear resistance of components or surfaces. Their chemical inertness can be used when they are mixed with coatings to help improve chemical resistance

more: Chemical Inertness 016, 018–019, 029, 036, 052–053, 088–089 Ceramic Spheres 106–107, 138–139

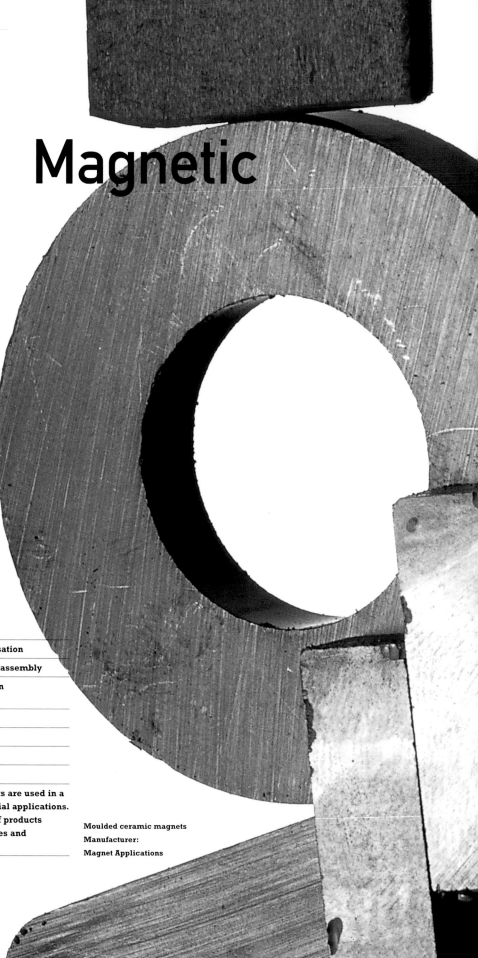

I like magnets; I like the way you can play with them. I used to like to test them on things around my mum's house to see which products were magnetic and which weren't; playing with those properties of attraction and repulsion and trying to lift things with the magnet or forcing two opposing sides together even when they really don't want to go.

Ceramic magnets, more commonly referred to as Ferrite magnets, are used in everything from fridge magnets to toys. They are nothing to look at — black, dirty and cheap. Their low cost goes some way to explaining why they are so popular, combined with properties which make them suitable for a range of environments and applications. Although magnets can be injection moulded ⬂, they are generally made by die-pressing powder ⬂ made up of 80% iron oxide and 20% barium or strontium oxide. The moulded components are then sintered at approximately 1200°C.

With these magnets available in an assortment of forms, like strips and tapes, they offer many potential applications. And who would have thought you could buy ceramics on rolls and cut them with a pair of scissors. Magnets are fun!

Magnetic

Key Features	Cost-effective
	Excellent resistance to demagnetisation
	Can be magnetised before or after assembly
	Operating temperatures of between –40°C to +250°C
	Good chemical resistance
	Good hardness
	Good resistance to corrosion
More	www.magnetapplications.com
Typical Applications	Sintered ferrite or ceramic magnets are used in a variety of industrial and commercial applications. They can be formed into a range of products including: blocks; rings; discs; tapes and flexible strips

Moulded ceramic magnets
Manufacturer:
Magnet Applications

Key Features	**Can be machined and cut using ordinary metal working tools**
	Withstands high temperatures, up to 1000°C
	No firing required after machining
	Non-porous and non-shrinking
More	**www.corning.com**
	www.precision-ceramics.co.uk
Typical Applications	**Electrical and thermal insulators; structural components; electrical equipment**

No tooling

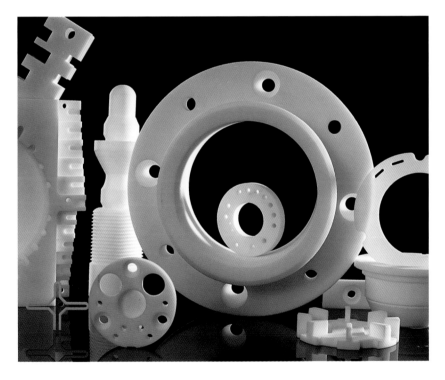

Macor® components
Manufacturer:
Precision Ceramics

So you've made that visual model, the stereo lithography sample looks great, but now you need to have the component tested in the right material. Ceramics can be the most immediate of materials, in the sense that you can manipulate a piece of clay with your hands. But then it needs to be fired, maybe glazed and it will also shrink once you have taken it from the kiln, which can sometimes make things awkward. Here you have a material with the benefits of ceramics combined with some of the machinable qualities of metals.

Macor is a strong, rigid material, which is pure white and can be polished. By drilling, grinding, turning, sawing, polishing and milling, it has processing qualities closer to metal than ceramic. The advantage of this strong, rigid material is that it is a ceramic which can be exploited by all of the above, which means there is no expensive tooling, contraction or movement during firing or frustrating delays. It is a material that is ideal for getting samples of prototypes or even low quantities of a ceramic component with less of the processing in between, which ultimately reduces development time and cost of fabrication.

Pre-formed

Obviously there are times when you don't want a powdered form of material from which you have to mould parts using potentially expensive tooling. Sometimes you just need semi-formed materials like sheets or rods from which you can further fabricate or machine. You may just want to buy a piece of Shapel® or Macor® ↘, which can be machined with standard metal working tools. Maybe you need the popular alumina ↘, which is available in thin, translucent sheets from which you might want to fabricate a product using a range of fixing methods like glass sealants or Super Glue, or even a special grade of cement.

Semi-finished materials
Manufacturer: Ceramic
Substrates and Components

Here are a wide selection of advanced ceramics that are available from the UK Company Ceramic Substrates and Components:

Graphite	**Available in the raw material form of rod, plate, tube all of which can be machined to the desired specification**
Dimensions	**On enquiry**
Macor®	**Available as bar, rod, tube or sheet**
Dimensions	**Maximum 305mm x 305mm x 58mm**
Shapel®	**Available as bar, rod, tube or sheet**
Dimensions	**Maximum 300mm x 300mm x 40mm**
Boron nitride	**Available in a range of different grades: Raw material bar, rod, tube or sheet**
Dimensions	**Depends on application**
Zirconia	**Available in a range of different grades: Raw material bar, rod, tube or sheet**
Dimensions	**Depends on application**
Silicon carbide	**Tube, rod not widely available as sheet**
Dimensions	**Depends on application**
Silicon nitride	**Bar rod tube not generally available as sheet**
Saphire	**Available in plate form**
Dimensions	**Depends on application**
Key Features	**Each material has its own specific properties. The main advantage for using semi-finished materials is that they enable designers to machine or assemble parts without the need for tooling, which can make it more cost-effective for short production runs**
More	**www.advancedceramicmaterials.com**

Range of Zodiaq® work surfaces
Manufacturer: Dupoint, USA

Hard-working

Dimensions	**1.3m x 3m, thickness 2cm and 3cm**
Key Features	**Excellent hardness**
	Good colour consistancy
	Non porous
	Excellent durability
	Heat resistant
	Stain resistant
More	**www.zodiaq.co.uk**
	www.zodiaq.com
Typical Applications	**Predominantly used as a surface material within a range of commercial and domestic applications. In the commercial arena, these include wall cladding, work surfaces, reception desks, bar tops, lab benches, kitchen counter tops and bath and shower surrounds**

Based on the Slavic word for 'hard', quartz ⬎ is a very versatile material. From its optic uses to use in piezoelectrics and watches, it has an abundance of useful physical and decorative qualities. This is a use for one of the most abundant minerals in the world, which exploits its hardness and unique aesthetic appeal as a surface material for work surfaces ⬎.

From Dupoint, the makers of Corian® the well-known brand of solid surface material comes Zodiaq®, a product made almost entirely of pure quartz crystals. This is a natural material employed for work surfaces that require visual appeal and good wear resistance. These are hard and uniquely decorated slabs. Visually, the crystals offer a light-playing and radiant effect with a three dimensional quality that can be seen by looking through the surface. Zodiaq® is offered in a palette of 16 colours with suggestive names that go from Cloud White to Space Black. And with the possibility to be machined, sandblasted and inlayed, it offers designers, architects and specifiers a whole new opportunity to bring ceramics out from behind the cupboard door and on to the counter.

more: Quartz 054–055, 062–063 Work Surfaces 122–123

Rugged elegance

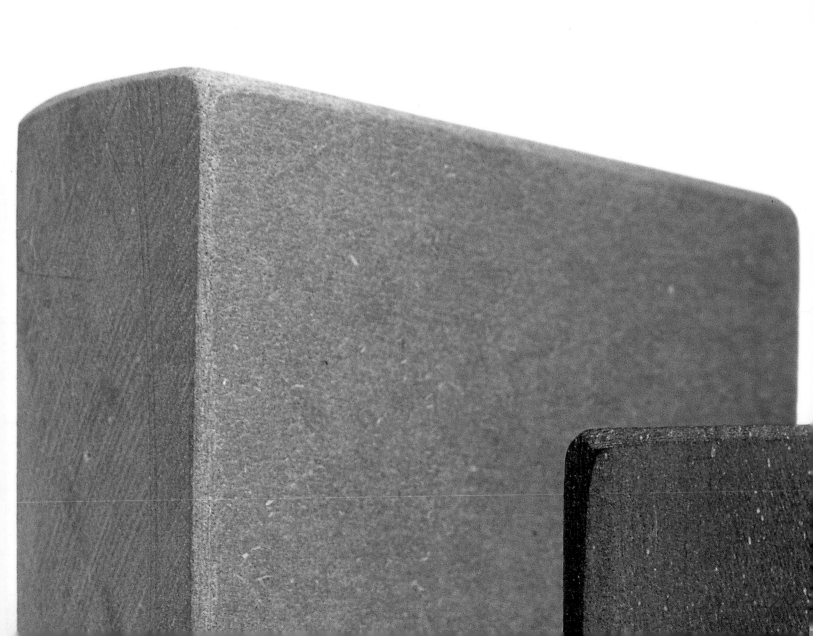

Take some Portland cement ↘, silica, water and fillers. Mix them together, place in an appropriately shaped mould and apply 400 tons of pressure. The result is Fireslate, a new entry into the world of hard surfacing products.

There are a range of surfacing materials ↘, each with their own properties and distinct aesthetic qualities. Each brings a new perspective on this type of product, but one of the key criteria they must all fulfil is hardness.

This is an interior use for cement, which offers the characteristics of stone and slate without the cost, which quickly absorbs the ambient warmth of the sun. In the market for decorative work surfaces ↘, it bridges the gap between low-cost, high-pressure, plastic laminates and expensive stones, slate and solid plastic materials.

When sealed with a silicon sealer, it feels smooth and cool with a satin finish like a beautifully lustrous pebble. With an understated, matt finish, the mineral richness of the three standard colours — graphite, light grey and pistachio — seem to soak any reflecting light.

Fireslate sheets
Manufacturer: Fireslate

Dimensions	Standard sheet size 2.45m x 1.375m
	Standard thicknesses 0.6, 1.2, 1.9, 2.6 and 3.2cm
Key Features	Hard, clean surface
	Resists stains and heat
	Custom fabricated panels
	Harder wearing
	Handles heat
	No burning characteristics
	No off gas
More	www.fireslate.com
Typical Applications	Counter tops, table and desktops, flooring, patios shelving, furniture, hearth and fireplace surrounds, mantels and wallboards

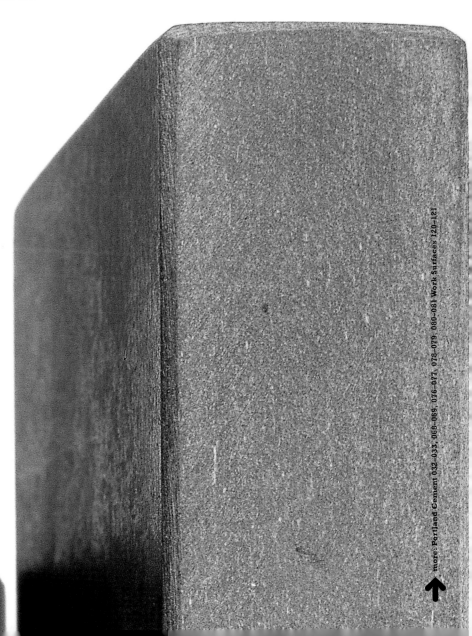

more: Portland Cement 032–033, 068–069, 076–077, 078–079, 080–081 Work Surfaces 120–121

Hard-wearing

Here's a new and up and coming type of floor and wall tile ⬎, which is made from a popular old friend. Ceramic materials are great for floors, they are brutally hard-wearing, have good decorative potential and are readily available. There are a lot of tiles that are suitable for either outdoor or indoor applications, but not often both, you have the granites and marbles etc but these aren't cheap.

So enter the ever popular and versatile porcelain ⬎, making yet another appearance. This time within an interior and architectural application. These porcelain tiles compete with the marbles and conventional glazed tiles by offering a balance of cost and excellent hard-wearing properties.

Available in a glazed and unglazed finish they are supplied in 10 colours and in as many ranges. The surface can be polished to a mirror-like shininess to look like glaze a straightforward matt or a slight bumpy stone effect. The polished finish is especially noteworthy as it looks like a glaze but is in fact not and unlike a glaze the surface can be re-polished if it fades with heavy usage on a floor.

Dimensions	3cm^2; 3cm x 6cm; 4.5cm^2; 6cm^2; thickness 9mm–1.1cm
Key Features	Frost proof
	No glaze
	Full body tile colour goes all the way through
	Cost-effective
	Hard-wearing
More	www.apavisa-porcalanico.com
	Uk Agent Tel: 01904 479593
Typical Applications	The features of porcelain means the tile can be used for interior or exterior applications. They can be used as floor or wall tiles and are ideally suited to flooring areas where there is a lot of pedestrian traffic, such as hotels, office foyers, airports and stations

Apavisa tiles
Manufacturer:
Apavisa Porcelanico

more: Tiles 091 Porcelain 044–045, 048–049, 054–055, 056–057, 060–061, 062–063, 066–067, 070–071, 072–073, 088–089, 090, 128–129

127 Dressing

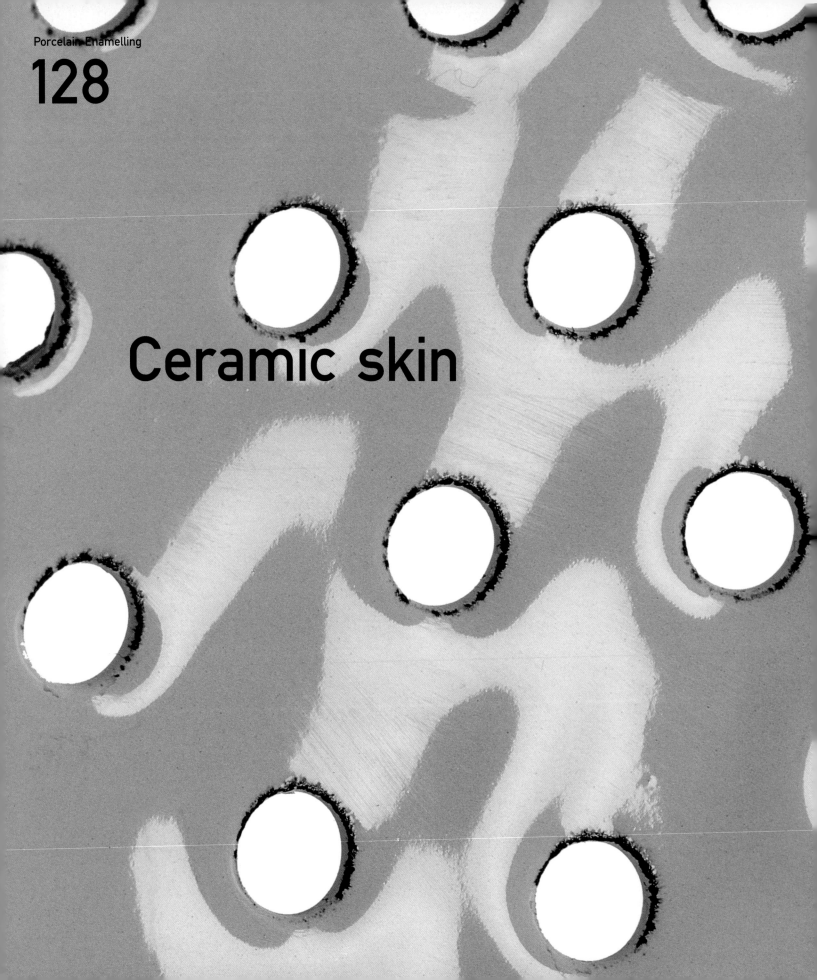

Ceramic skin

This is no ordinary semi-permanent finish. Porcelain ⟍ enamelling ⟍ is tough. Early advertising and London Underground signs from the first part of the 20th century, together with granny's old enamelled cooking pots, provide the evidence that, once applied to a metal, porcelain enamelling is there to stay and will not fade like many of its modern competitors.

This metal ceramic combination allows the end products to share the best properties of each material: the manufacturing possibilities of metal combined with a glassy, brutally impenetrable finish. From ovens to cookware ⟍ and bathrooms, it has a functional hardness that protects surfaces from wear while also giving designers the potential for decoration.

Based on a form of alumina borosilicate glass, the non-burning and fire-resistant ⟍ finish can be applied to a range of metal substrates through dipping, spraying and wet or dry application through an electrostatic gun. During the process, it becomes fused to the metal (generally carbon steel, stainless steel, cast iron or aluminium) at temperatures from 1000°F–1600°F.

Whether you call it porcelain enamelling, vitreous enamelling or glass on steel, this scratch-resistant, weather-proof, corrosion-resistant skin is a highly effective coating which is ideal for applications where heat and fire resistance is important.

Key Features	**Extremely durable**
	Resistant to chemicals
	Heat- and flame-resistant
	Hygenic
	Stable colour does not deteriorate after time
	A range of finishes and texture
More	**www.burnhamsigns.com**
	www.ferro.com
	www.ive.org.uk
Typical Applications	**Cookware; bath; sanitary finish on large and small appliances; as well as sanitaryware; water heaters; building panels; signage and chemical storage vessels; sewage treatment tanks; jewellery and decorative boxes**

Enamelled colander
Manufacturer: Unknown

130

Electronic ceramics

Imagine conductive cups and saucers and other everyday banal objects that can talk to each other; a world where plates can talk to other electronic products in the kitchen, where conductive electronic circuits can be applied to ceramic objects.

Thick-film metallising offers the potential for the physical properties of two materials to be joined together for a common interest. This is a network of conductive tracks, resistors and capacitors placed over a ceramic substrate used for applications where standard fibreglass PCBs just won't do. It is a process for screen-printing precious metals like silver, gold and platinum ↘ onto ceramic substrates. Apart from the advantages offered over conventional fibreglass PCBs, these ceramic circuits have a much higher operating temperature. They also differ in that they add material rather than etching it away.

The process involves screen-printing layers of the metals onto what is usually alumina or aluminium nitride, which is then fired to make a permanent physical bond. Subsequent layers can be added to form separate circuits. These are sandwiched between non-conductive barriers that allow for a complex grid of circuits that can function independently or together.

This is an industrial process that invites designers to explore the crossover of ceramics and electronics.

Key Features	Higher operating temperature than conventional PCBs
	High adhesion strength
	Custom-designed electronic circuit
	Can be printed single- or double-sided
	Insulation
	Excellent mechanical properties
	High level of accuracy
	Plated-through holes, unusual shapes, different thicknesses
More	www.ceramtec.de
	www.coorstek.com
	www.ukgeneralhybrid.com
	www.4hcd.com/tfabout.html
	www.hlt.co.uk
Typical Applications	Products range from custom-designed thick-film hybrids and surface-mount assemblies to standard products such as high voltage, high-value resistors, specialised resistor networks and chip resistors. Applications are diverse, ranging from consumer through to military requirements

Electronic ceramic
component parts
Manufacturer: UK
General Hybrid

more: Platinum 042–043, 132–133

MH1721 HIGH

RESISTOR INK TEST

7 8

11

MAX. & MIN. AFV'S

Dimensions	42cm x 50cm x 26cm
Key Features	**Hand-painted**
	Decorative
	Chemically inert
	Hard wearing
	Huge range of decorative finishes, colours and textures
More	**www.geringgalery.com**
	www.karimrashid.com
Typical Applications	**The use of hand-painting in applying glaze allows for total freedom on the surface of a ceramic piece. It is not only used in studio pieces but also on the production line**

Precious glaze

Over the last five years, Karim Rashid's work ↘ has crossed many disciplines blurring boundaries between product, furniture, spatial and packaging design. His products have been produced by some of the most high profile companies in the world. This range of ceramic objects explores the use of metallic glazes to heighten the sensual experience of their form. Its natural ability to accept adornment and the permanence of a glaze makes ceramics a highly valuable base for applying decoration.

'These ceramics were produced just as ceramics were made in ancient Egyptian and Roman times (the Blob collection is a homage to my heritage, to the urns and vases of Rome and Egypt). Gold and platinum ↘ glazes are fastidious and delicate. The forms had to be perfectly smooth for the glaze to adhere properly. The spraying effect or gradation was something new we tried and experimented with. Also, since fluorescent pigment does not exist in a glaze, the interior fluorescent colours were actually painted on by hand and then clear-coated after firing in the kiln,' says Karim.

'The idea to use ceramics came before the form. The forms were generated by wireframe 3D solid modelling software and then translated into handmade objects.

'The ceramic, in this case, was all developed by hand without moulds so the pieces are very crafted by real ceramic maestros in Rome.'

Grid to Blob series
Designers: Karim Rashid
in conjunction with
Joane Gurwander
Date: 2002

more: Karim Rashid 008–009 Platinum 042–043, 130–131

Second skin

It is easy and generally a wasted opportunity to think of materials only as the basis for making things. Think of materials in terms of how heavy, strong, predicable, mouldable. Can they be carved, blown, cast, pressed, etc? In many design industries, these criteria are the usual starting points. The emphasis on surface decoration generally only comes from the moulding or forming of the material and in this sense is restricted.

One advantage of ceramics over other materials is the possibility for surface adornment: the ability to create a surface of equal if not of more importance than the form, to draw in the viewer through the layering of skins. When discussing the manufacture of many ceramic products, there has to be an understanding of this process.

Dick van Hoff creates an unusual alternative to the glazed skin traditionally used to decorate ceramics. He has produced a series of plates where the automatic mixing of two colours in the extruding machine creates a different pattern on each plate. In essence, the design is taken out of the hands of the designer and into the random hands of the machine.

Two-colour porcelain protoype
extrusion plates
Designer: Dick van Hoff
Year: 1997

Dimensions	**25cm diameter**
Key Features	**Protective**
	Decorative
	Chemically inert
	Hard-wearing
	Huge range of decorative finishes, colours and textures
More	**www.www.droogdesign.nl**
Typical Applications	**It is impossible to pick categories for applications of glazes. They are used for ceramics products from tableware to sanitary ware, decorative pieces and studio pottery**

Science and art

Ceramics are one of the few materials where the design on the surface has developed into an area of creativity and importance to the same degree as the material itself. These screen-printed pieces form part of a project by Rob Kesseler where the intention was to exploit nature's unseen world.

Bringing together the worlds of science and art Rob set out to examine and celebrate English Lakeland flora. Pollen collected from wild flowers was photographed on a scanning electron microscope at Kew Gardens and the resulting images were used to develop a collection of burnished gold and enamel ceramic prints for a dinner service for Grizedale Forest and a tea set for Dove Cottage, home to William Wordsworth.

Kesseler's process involved technology on several levels. First the pollen was photographed through the electron microscope. This image was then scanned into a computer where various filters were used to refine the image, which was then outputted onto a transparent laser film. The image was then printed through the screen onto a coated paper, which, when dry, was put into a bath of water which released it as a transfer. Once the transfer was applied to the piece, it was fired at 750°C to 900°C.

Dimensions	**27cm diameter**
Key Features	**Good process for short runs**
	Not suitable for compound curves
	Straightforward setting
	Allows for several layers to be built up
More	**www.graft-uk.com**
Typical Applications	**This process is used for an assortment of different product from tableware to tiles. A slightly different process involves the print being applied directly to the surface, which is used for a variety of products**

Gathered dinner service
Designer: Rob Kesseler
Manufacturer: Grizdale Forest
Date: 2000

Key Features	Resists cracking and peeling
	Over time more cost-effective than normal paint
	Good thermal barrier
	Superior bonding capabilities
	Breathable
More	www.liquidceramic.com
Typical Applications	This is an interior or exterior paint, which is used for domestic and industrial applications to help offer thermal insulation

Liquid

The places where I find materials to have the most exciting uses are in the products where you least expect to find them: those products where you wonder how ceramics could be used in such an unlikely place. We've seen ceramic used in flexible papers ⬊ and fabrics ⬊; now we have ceramics as a liquid.

This is one of those products that find our usually brittle, hard friend applied in a microscopic form. It is somewhere that finds uses more for its physical and mechanical properties than for its looks. The idea behind this thermal coating is the fact that certain ceramics demonstrate good thermal insulation (as demonstrated in the space shuttle ⬊). This idea has been applied to a product that has a far more domestic use: the blend of paint and ceramic makes this coating much more than any normal paint. It provides a liquid surface which when applied to walls allows the surface to breathe but at the same acts like a thermal barrier. The polymer-based paint contains millions of microscopic, hollow ceramic spheres ⬊, which function as tiny thermos bottles to make the paint breathable, waterproof and good at keeping out ice-cold temperatures ⬊, high winds and rain.

Liquid Ceramic™
applied to wood
Manufacturer: Liquid
Ceramic International

141 Appendices

Processing

The production of ceramic objects is one of the oldest crafts. Ceramics is a material that is not specific to any country or region; rather, industries were built around quarries where the clay and coal were readily available. Production is not limited to specific regions and manufacturers rely less on traditional communities, fuelled instead by the global economy to open plants around the world.

The process of forming ceramics consists of three main areas. First, the preparation of the ingredients of the ceramic. In this case, the raw material comes in powder granules which is blended in either wet or dry forms. If the mixture is used wet, then the right degree of plasticity is obtained by mixing plastic clays with non-plastic ingredients.

The next stage is the forming of the part and, finally, in most cases, drying and firing, or sintering. As with most materials, ceramics can be formed in a number of methods to account for low-, medium- and high-volume production.

Acid etching
Firstly, a pattern is created on a transfer. This is soaked in water to release the film from its paper backing. The pattern is made up using black ink. Once the transfer is applied to the ceramic piece, it is dipped in acid, at which point the non-covered area is attacked by the acid to produce the shallow indentation.

Casting
This generally involves using slip. It can also take various forms, such as high-pressure casting or traditional slip-casting.

Coiling
A simple and traditional hand-worked method of making large containers, using coils of clay wound around to gradually build up the shape.

Drying
The presence of excessive moisture during firing results in a damaged final piece. Once a ceramic product has been made using a wet material, it needs to be carefully dried before it can be fired. The process must be slow, as rapid water evaporation will cause cracking and uneven movement, which leads to warping. In industry, objects are dried and fired on a slow-moving conveyor belt through a long oven.

Extrusion
Simple and complex cross-sectional shapes can be produced using extrusion. The process is based around a plastic clay mixture being forced through a die. Long lengths of the shape are produced which can then be cut down. This is an ideal process for products and components of the same cross-sectional shape. Typical extruded products include bricks, pipes and electrical conduits.

Firing
Apart from some advanced ceramics which do not need firing, all ceramic products need to be fired or sintered in order to be useable. The conditions and firing temperature required depend on the material. Some pieces need several firings, beginning with a biscuit-firing and ending with a firing for the glaze.

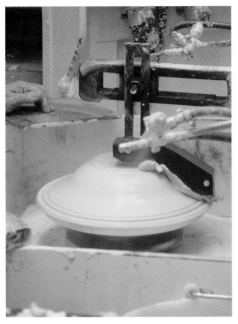

jiggering

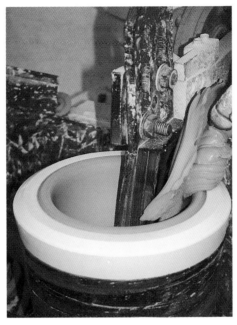

Jollying

Moulds for slip-casting

Jiggering

This process is used for making flatware from a wet clay. A pancake of clay is placed over a revolving mould to form the inside shape while a metal profile forms the outside. This process has largely been replaced by powder-pressing, which operates at faster rates and is automated. Jiggering is still used for making items with small production runs.

Jollying

This is similar process to jiggering, used to make hollow-ware. In this case, the metal profile is used to form the inside of the piece. Stages of jiggering and jollying are explained in detail on pages 092–093.

Hand-painting

Hand-painting is not restricted to expensive tableware, but is also used to apply glazes on mass-produced giftware and figurines.

High-pressure-casting

This is a variation on the slip-casting process. The slip is formed under pressure in the plaster mould, which speeds up the process.

Injection moulding

This is a widely used process in forming polymer-based products, but less widely used in the ceramics industry. Traditionally, the ceramic is mixed with a polymer resin to provide the correct plasticity when it flows into the mould. The resin is burned off during firing. These binders can cause problems and are expensive. Binderless injection moulding has been developed by Ceram Research UK.

Machining

Only certain ceramics are machinable. Methods include milling, sawing, grinding and lathe work.

Pressing

This process can be performed using wet clay or dry granules. In this automated process, the ceramic powder or clay is forced into a cavity formed by two steel moulds under high pressure. This is a suitable process for making precise components for the ceramic electronics industry, where high tolerances can be achieved.

Ram-pressing

This is a sanitary and tableware-making process which uses two porous moulds to squash a ceramic body. Ram-pressing is usually employed to make thick-sectioned pieces.

Slip-casting

Slip-casting is based on slip, a creamy suspension of clay in water. This is poured into plaster moulds where it is allowed to dry. This occurs first on the side closest to the mould, forming a thick skin (the longer it is left, the thicker the skin). After a sufficient build-up of dry clay, the remaining slip is poured away, leaving the final product to be dried and fired. Slip-casting is ideal for large and intricate shapes.

Turning

Used for making round, symmetrical products. The starting point involves mixing the clay to form an appropriate body, which can be extruded into a long piece of clay. This can then be cut up into small pieces which, when leather-hard, are fixed to a lathe and turned. This method of forming products from ceramics is ideal for small production runs, as it does not involve large tool costs.

Ceramic terms

Ball clay

Takes its name from the way it was originally mined as balls. It is a highly plastic clay that is often combined with other clays.

Biscuit/bisque

Refers to a ceramic that has been fired but not glazed. The firing takes place at around 1000°c. A ceramic piece that is biscuit-fired is porous and subsequently is not waterproof.

Bloating

An imperfection in the clay due to over-firing.

Body

The prepared ceramic mixture, which is generally a mixture of various clays.

Body stain

Colour introduced directly into the body.

Ceramic fibre

A similar material to glass fibre which is used for thermal insulation.

Combing

A method of applying a surface texture to a ceramic piece using a blunt comb.

Crackle

Deliberate form of crazing used as a decorative effect, sometimes to make something look old.

Crazing

An imperfection in the glaze which appears as a fine cracking.

Enamels

Low firing decorative glaze applied over a previously fired higher glaze.

Feldspar

White crystals found in granite. Used as a fluxing agent in glazes.

Fettling

A final cleaning up of a ceramics piece before it is fired.

Fired size

The final size of a ceramic piece, taking account of shrinkage that takes place in the kiln.

Flatware

The opposite to hollow-ware which, as the name suggests, describes products like plates, saucers and shallow dishes.

Glaze

A hard coating of glass applied to the surface of ceramics as decoration and to seal porous bodies.

Hollow-ware

As opposed to flatware, this describes hollow volumes like teapots, bowls, cups, jugs, etc.

Leather-hard

When clay has lost moisture, it can be moved easily without cracking and can be joined using slip.

Pottery

A clay material that has been exposed to a high temperature which results in a chemical change.

Slip

A liquid, pourable clay used to cast with. Made from clay suspended in a water to create a fairly viscose, creamy consistency.

Slurry

Similar to slip but not sieved or prepared to the same degree. It is used for joining ceramic pieces together.

Turning

A process used to make round, symmetrical pieces, which works by rotating a leather-hard ceramic and cutting away the material to form the final shape.

Vitrification

The heat of firing transforms the silica contained in the body to glass, which bonds the ingredients together. This creates a non-porous material which is able to hold liquid. Porcelain, china and stoneware are vitrified ceramics.

Wedging

A process used to mix and pound clay together to eliminate air pockets, creating a homogenous mixture.

Mechanical properties

Material properties are used informally in this book. However, when referring to toughness, it is important that the correct meaning is understood and how it is different to hardness. The are many properties used in evaluating materials, below are some of the most frequently used terms. They encompass mechanical, chemical and thermal properties.

Brittleness

Used to describe a material that breaks without giving any visible signs or without prior deformation.

Compressive strength

In effect, the opposite to tensile strength. Compression is a force applied to a material, which shortens the length and widens the cross-sectional area.

Conductivity

Applied to both heat and electricity, it is the speed at which a material transfers energy.

Creep

The amount a material slowly distorts under pressure.

Ductility

The ability of a material to be permanently deformed under tension without fracturing.

Elasticity

The ability a material has to return to its original dimensions after a force is applied.

Fatigue strength

The ability to withstand repeated force or pressure.

Flash point

The lowest temperature at which a material or its vapour ignites.

Hardness

A hard material is one that resists indentation, scratching, wear and abrasion and is difficult to machine. Ceramics is one of the hardest materials.

Hygroscopic

A material which absorbs and retains moisture easily.

Impact strength

The ability of a material to absorb the energy of a sudden blow.

Malleability

The ease with which a material is deformed permanently by compression without fracturing.

Plasticity

The ease with which a material permanently deforms under low pressure.

Porosity

The volume of open pores in a material in relation to the overall volume of the material. A sponge, for instance, is highly porous.

Shear strength

This is the action of two forces working in opposite directions over a piece of material. Forcing part of the material to slip over another. The point at which a fracture occurs under a load.

Specific gravity

The weight of a given volume of a material compared to the weight of an equal volume of water at 4°C.

Specific heat

Energy required to heat 1g of a given material by 1°C.

Stiffness

The ability of a material to withstand deflection. Based on the ratio of stress to movement.

Static strength

The ability of a material to withstand an applied stress resulting in deformation.

Stress

Tensile, compressive or shear stress is the pressure externally applied to a material, which causes fracture.

Tensile strength

In simple terms, the amount of stress that a material is able to withstand when stretched.

Thermal expansion

The ratio between increase in temperature and increase in dimension of the material.

Toughness

The ability of a material to absorb impact energy without breaking. Ceramics are generally not very tough, but are very hard.

146

Types of ceramics

There is a vast range of ceramic materials and grades used over the mass of industries that they infiltrate. Apart from the more traditional materials, such as porcelain, clay and terracotta, there are advanced ceramics that consist of various types of oxides, nitrides, borides, carbides, and silicates.

The general characteristics of ceramic are:

Excellent hardness
High melting points
Good thermal stability
Excellent stiffness and rigidity
Generally brittle

Wine Pot
Designer: Martin Szekely
Gallery Kreo
Date: 1998

Aluminium nitride	Is specifically of interest for its very high thermal conductivity in combination with its effective electrical insulation. It can be produced by dry press and sinter or by hot pressing with sintering aids. The material suffers surface oxidation above 700°C. Applications are in the electronics area where heat removal is important. Another characteristic is good corrosion-resistance.
Alumina (aluminium oxide)	The most widely used advanced ceramic because of its balance of cost, availability and good mechanical properties. It offers a combination of good mechanical and electrical properties leading to a wide range of applications. Alumina can be produced in a range of purities with additives designed to enhance properties. It can be formed using many ceramic processing methods and can be machined or net shaped to produce a wide variety of sizes and shapes of component. In addition, it can be readily joined to metals or other ceramics using metallising and brazing techniques. Typical characteristics include good strength and stiffness, good hardness and wear-resistance, good corrosion-resistance and good thermal stability.
Bone china	Developed in England in the 19th century as a result of trying to produce porcelain. Bone china consists of 50% bone ash (hydroxy-apatite), which gives it its translucent and hard characteristics, 25% kaolin and 25% quartz, feldspar and mica.
Cement	A powdered mixture of limestone, clay and shale. By adding water, the powder is set and can be used for moulding. Adding too much water reduces the hardness of the cement. If it is not enough, the chemical reaction does not fully take place and the cement will not harden. The most common form of construction cement is Portland cement.
Chalk	A block form of high-grade talc used for writing.

China clay (kaolin)	A pure form of hydrated aluminium silicate used to make porcelain for a range of electrical and standard porcelain bodies. China clay is made of kaolinite mica and quartz. Visually it does not have the translucency or hardness of bone china.
Clay	Found in a variety of forms all over the world, each with distinctive characteristics. Formed by rocks, which have been broken down and decomposed by natural weathering. Its mouldable properties make it a basic ingredient for many products.
Concrete	When set, it forms a stone-like material with its biggest application in the construction industry. Concrete is a mixture of cement, sand and an inert aggregate, which can be any number of materials but is usually small stones.
Cornish stone (China stone)	Less decomposed than china clay containing a large amount of feldspar. Generally used as a flux and porcelain bodies.
Earthenware	A porous, non-waterproof clay. Fired at a relatively low temperature of 1150°C, it must be glazed in order to hold liquids. Easier to work with than bone china or porcelain, earthenware is the workhorse of traditional ceramics.
Glass ceramic	One of the main advantages of glass ceramic is that it can be readily machined into complex shapes and precision parts using ordinary metalworking tools, quickly and economically. No post firing is required after machining, ensuring fast turnaround. Glass ceramic typically withstands high temperatures up to 1000°C. It is non-wetting, exhibits zero porosity and won't deform. It is also an excellent insulator at high voltages, various frequencies and high temperatures and offers excellent sealing, joining and metallising performance. It also has zero porosity, does not shrink and withstands high temperatures up to 1000° C.

Graphite	A type of carbon, graphite is available in several forms: pyrolytic graphite, recrystallised graphite, fibres, colloidal and piezoelectric graphites. Characterised by relatively low strength at room temperature but unlike most materials, its strength increases with temperature up to a maximum of 4530°F. It also has an excellent strength-to-weight ratio.
Granite	Made up of mica, feldspar and quartz. It comes in many forms and is distinguished by its hardness, durability and good weatherbility. The material can be used as a building material and its decorative effects can be enhanced by polishing to emphasise its crystals.
Jasper	A stoneware developed by Josiah Wedgewood.
Kaolin	See china clay.
Magnesia (magnesium oxide)	Dense magnesia is not normally used as an engineering ceramic. However, lower density magnesia, for example with 30% porosity, is used in a variety of applications due to its electrical and refractory properties. Typical characteristics include high temperature capability, low electrical conductivity, high thermal conductivity, good corrosion-resistance and infrared transparency.
Oxides	A family of ceramics made up of single or double oxides. Single oxides include aluminium oxide, magnesium oxide and zirconium oxide. In the double oxide family there is steatite, cordierite, forsterite and zircon. Each material has its own distinct properties but can be characterised by relative low cost compared to other advanced ceramics, high density and ability to produce high tolerances.
Plaster of Paris	Composed of gypsum, which is hydrated calcium sulphate. In ceramics production it is generally used for making moulds. Becomes solid when mixed with water.

Porcelain	Hard, vitrified, white and translucent ceramic, normally fired at over 1300°C. It is used in a vast range of industries, which include electrical insulators, formers in production and teacups. Depending on the final application, it generally contains clay, quartz, feldspar and kaolin. There are different grades of porcelain depending on the final application, these include electrical, chemical and vita porcelains that are used in dentistry. Key features include good hardness, excellent chemical resistance and low thermal shock resistance.
Pyrolytic boron nitride	Pyrolytic Boron Nitride (PBN) is a white solid material that is non-porous and non-toxic. While boron nitride can be formed by pressing/sintering methods, this high purity pyrolytic material is formed by a vapour deposition process. PBN is also a very good electrical insulator and has very high thermal conductivity. The material is stable and inert and reducing atmospheres up to 2800°C, and in oxidizing atmospheres to 850°C. Typical characteristics include: high thermal conductivity, low thermal expansion, good thermal shock resistance, high electrical resistance, good chemical resistance and low density.
Quartz	The most common form of silica is composed of hexagonal crystals and in its natural, pure state is colourless and pure. It is mainly found as granules and is one of the key ingredients in porcelain and china clay.
Refractory materials	Materials that can withstand extremely high temperatures. They are used in the construction of furnaces and kiln furniture.
Silicon dioxide	One of the most common materials on the planet. Sand, rocks and clays all largely made up of silica. It is one of the main elements in glass. Fused silica is a form used in making glass with extremely high temperature requirements. It withstands thermal shock extremely well.
Silicon carbide	Silicon carbide (SiC) is highly wear-resistant and also has good mechanical properties, including high temperature strength and thermal shock resistance. SiC, as a technical ceramic, is produced in two main ways. Reaction-bonded SiC is made by infiltrating compacts made of mixtures of SiC and carbon with liquid silicon. The silicon reacts with the carbon, forming SiC. The reaction product bonds the SiC particles. Sintered SiC is produced from pure SiC powder with non-oxide sintering aids. Conventional ceramic forming processes are used and the material is sintered in an inert atmosphere at temperatures up to 2000°C or higher. Other characteristics include: low density, high strength, oxidation resistance (reaction-bonded), excellent chemical resistance and high thermal conductivity
Silicon nitride	Silicon nitride is produced in three main types; reaction-bonded silicon nitride (RBSN), hot-pressed silicon nitride (HPSN) and sintered silicon nitride (SSN). RBSN is made by direct-reacting compacted silicon powder with nitrogen, and produces a relatively low-density product compared with HPSN and SSN, however the process has only a small volume change allowing net shape forming. HPSN and SSN materials are made with sintering aids and offer better physical properties suitable for more demanding applications. Key features include good thermal shock resistance, good high temperature strength, low density, good hardness and wear resistance, high fracture toughness, good oxidation and chemical resistance and good creep resistance.

Steatite	Steatite is a magnesium silicate material. It is formed using standard ceramic processing methods and can readily be machined or net shape sintered into a variety of forms. The material is lower in cost than alumina but has reduced mechanical properties. However, steatite has very good electrical resistance properties which are retained at high temperatures, along with moderate mechanical strength and temperature resistance. It has been used in electrical insulation for many years in both large-scale electrical systems and electronic and domestic appliances.
Stoneware	A vitreous, non-porous ceramic but unlike china or porcelain is opaque. Key features include water resistance, good hardness, excellent chemical resistance, low thermal shock resistance and low tensile strength.
Talc	A hydrated magnesium silicate used for a variety of applications. In its pure white state it is used as a cosmetic. In powdered form it is used as a filler for plastics and for paper coatings. Steatite is a type used in solid block form for electrical insulation
Terracotta	Low-fired, unglazed clay with a distinctive red and orange colour, although other shades are available and white terracotta is also obtained. Terracotta is generally used as a material for exterior applications such as tiles, plant containers, and hollow building bricks due to its ability to withstand frost.

Titanium dioxide (titania, titanium oxide)	While titania is used in large quantities in powder form, bulk-sintered material has limited mechanical applications, due to its relatively low fracture toughness compared to alumina. This material is tan in colour, and has been used to produce threadguides where there is relatively soft wear on the yarn. In addition, the material can be produced in a reduced form, black in colour, that is electrically conductive for threadguide applications where static electricity is a problem. Typical characteristics include low-friction, high thermal conductivity, corrosion-resistance, strength, high dielectric properties in pure form and electric conductivity in reduced form
Zirconia (zircomium oxide)	Zirconia offers chemical and corrosion resistance to temperatures well above the melting point of alumina. In its pure form crystal structure changes limit mechanical applications, however stabilised zirconias produced by the addition of calcium, magnesium or ytrium oxides can produce very high strength, hardness and particularly toughness. In addition the material has low thermal conductivity and is an ionic conductor above 600°C. This has lead to applications in oxygen sensors and high temperature fuel cells.
Zirconia-toughened alumina	Zirconia-toughened alumina (ZTA) is used in mechanical applications. It is considerably higher in strength and toughness than alumina. This is as a result of the stress-induced transformation toughening achieved by incorporating fine zirconia particles uniformly throughout the alumina. Typical zirconia content is between 10 and 20%. As a result, ZTA is more expensive than alumina but offers increased component life and performance. Other typical characteristics include excellent wear-resistance, high temperature stability and good corrosion-resistance.

Objects

www.dyson-ceramic-systems.com

Market leaders in the supply of kiln furniture.

www.ukceramics.org

Shows contemporary work by new, emerging and established ceramicists and studio potters working in the UK.

www.armitage-shanks.co.uk

Sanitary ware

www.studiopottery.co.uk

Information on British studio ceramics.

www.gcpflolite.com

Producers of lightweight, non-carcinogenic insulation products as an alternative to ceramic fibres.

www.mmg-neosid.com

MMG GB manufactures an extensive range of soft ferrite components and accessories used in the industrial, computer, telecommunications and automotive/aerospace industries.

www.magnetsales.co.uk

Magnets

www.dsf.co.uk

Suppliers of high-quality products for high-temperature applications and arduous conditions in the heat containment industries of the world, including iron and steel, glass, cement and other rotary kilns, as well as non-ferrous metals, incinerators and brick and ceramic kilns. A leading producer of high aluminia refractory bricks and blocks, in standard sizes and special shapes and a complete range of products based on chamotte, andalusite, mullite, bauxite, spinel and pure alumina. Shapes are produced by both pressing and casting techniques, and products are fired at high temperatures.

www.cotronics.com/

High-temperature speciality materials including adhesives, coatings and ceramic paper.

www.faireyceramics.com/

Manufacturers of a range of quality ceramic products including ceramic porous products, ceramic water filters.

Building

www.makersgallery.com/concrete/links.html

Andrew Goss's work combines metal and concrete.

www.ibstock.co.uk

Manufacturer of high-quality clay-facing bricks and paving, special shaped bricks, architectural terracotta, faience and cast stone.

www.construct.org.uk

Association of member companies dedicated to improving the efficiency of building in-situ concrete frames and associated structures.

www.cement.bluecircle.co.uk

Lafarge Cement is the largest manufacturer of cement in the UK.

www.castlecement.co.uk

Castle Cement, the UK arm of Heidelberg Cement Group, one of the world's largest cement producers.

www.matthey.com

Speciality chemicals company focussed on its core skills in precious metals, catalysts and fine chemicals. It is organised into four global divisions: Catalysts & Chemicals, Precious Metals, Colours & Coatings and Pharmaceutical Materials.

www.imerys-structure.com

Building materials division of Imerys. Producers of tiles, bricks and chimney blocks.

www.keymer.co.uk

Hand-made clay tiles using wealden clay.

www.porcelanosa.com

Implements advanced ceramic materials and innovative designs into contemporary architecture.

http://nyscc.alfred.edu/mus/conspicuous/conspicuous.html

Conspicuous Applications of Advanced Ceramics: a special exhibition at The International Museum of Ceramic Art at Alfred

www.yorkhandmade.co.uk

Range extends beyond hand-made bricks: terracotta floor tiles, landscape pavers, garden edgings and various specials.

www.ceramicacollado.es

Wide range of ceramic products for the building trade.

www.johnson-tiles.com

H & R Johnson is the largest UK manufacturer of ceramic tiles.

Tableware

www.royal-crown-derby.co.uk

Produces bone china tableware, giftware and collectables.

www.rorstrand.se

Europe's second oldest china manufacturer of contemporary china.

www.portmeirion.com

British ceramics manufacturer.

www.kahlaporzellan.com

The largest porcelain manufacturer in Thuringia, Germany.

www.fuerstenberg-porzellan.com

One of Germany's most prestigious manufacturers of hand-made and decorated fine china.

www.kosemilano.com

Manufacturer of hand-crafted, historical objects.

www.patraporcelain.com

Leading manufacturer of porcelain tableware in Thailand.

www.spal.pt

Portuguese tableware producer.

www.rb-bernarda.pt

Earthenware company manufacturing ceramics in Alcobaça.

www.hudsonandmiddleton.co.uk

Manufactur of quality fine bone china mugs, teaware and kitchenware.

www.royal-doulton.com

Leading UK manufacturer also includes websites for Minton, Royal Albert, Paragon, John Beswick and Enchantica brands.

www.royalstaffordtableware.co.uk

Combination of two famous pottery factories: Royal Stafford China and Barratts of Staffs.

www.royal-worcester.co.uk

Blend art and rigorous craftsmanship to create exquisite products.

www.spode.co.uk

Traditional English tableware.

www.wedgwood.co.uk

Traditional and contemporary English tableware. Holding company for many other well-known manufacturers.

www.arabia.fi

Contemporary Finnish tableware.

wwwhere.else

www.nymphenburg-porzellan.com

Elegant and extravagant hand-made pieces.

www.rosenthal.de

Traditional and contemporary German porcelain tableware.

www.denbypottery.co.uk

Denby Pottery are renowned for their stylish, quality tableware.

www.masoncash.com

Manufacturer of traditional products made from local materials.

Magazines

www.ceramic-society.co.uk

Ceramics in Society is a quarterly, full-colour UK magazine.

www.ceramicbulletin.org

Journal published by the American Ceramic Society: a world resource for ceramic manufacturing and technology.

www.ceramic-review.co.uk

Ceramic Review is a global magazine for potters, students, enthusiasts and collectors.

www.ceramicsmonthly.org

Ceramics Monthly is an internationally distributed magazine on ceramic arts and crafts.

www.claytimes.com

Clay Times is a bi-monthly magazine covering contemporary work as well as influential artists and events from the past.

Associations/Institutes

www.rcc-info.org.uk

Reinforced Concrete Council.

www.tiles.org.uk

The Tile Association represents manufacturers, tile fixers, distributors, retailers, agents, shippers and supports companies such as adhesive and accessory manufacturers.

www.dkg.de

Deutsche Keramische Gesellschaft e.v.

www.ikts.fhg.de/vl/ceramics.html

Virtual library of technical ceramics. Loads of links.

www.ceramics.mmat.ubc.ca

Ceramics Group at the University of British Columbia.

www.iom3.org

The leading international professional body for the advancement of materials, minerals and mining to governments, industry, academia, the public and the professions.

www.tms.org

The Minerals, Metals & Materials Society (TMS).

www.bathspa.ac.uk

National Association for Ceramics in Higher Education.

www.geopolymer.org

Geopolymers.

www.kemi.dtu.dk

The Danish Ceramic Society (DaCerS) specialise in electroceramics, fuel cells, ceramic superconductors and catalysts

www.advancedceramics.org

United States Advanced Ceramics Association (USACA) is the premier association that champions the common business interests of the advanced ceramic producer and end-user industries.

www.craftscouncil.org.uk

The Crafts Council is the UK's national organisation for the promotion of contemporary crafts and applied arts.

www.ceramics-online.it

Associazione Italiana Città della Ceramica (AICC) is a non-profit association that works to enhance Italian ceramics.

www.ceramfed.co.uk

The British Ceramic Confederation.

www.ceramics.nist.gov

Ceramic division for the National Institute of Standards and Technology.

www.acers.org

The American Ceramic Society (ACerS) is an international association that provides the latest technical, scientific and educational information to the ceramics and related materials communities.

www.ceramicindustry.com

The global voice of ceramic manufacturing, promoting the interests, growth and progress of the ceramic, glass and brick industries.

Material

www.potterycrafts.co.uk

Range of products and materials, including types of clays and slips.

www.grantadesign.com

Leading materials information technology (IT) provider, supplying the world's first and only comprehensive materials IT system.

www.matls.com

Material properties database includes ceramics and other materials.

www.mkt-intl.com

Marketech International, Inc. offers advanced materials including Aerogels, electro-chemicals, single crystals, fuel cells, superconductors, engineered ceramics, alumina ceramics, raw materials, powders, sputtering and evaporation targets.

www.wbbminerals.com

Sibelco Minerals and Chemicals Ltd. is a major supplier of industrial minerals and chemicals including silicas, dolomite, prepared clay bodies, industrial resins, resin-coated sand, foundry fluxes, refractory coatings and related products.

www.imerys.com

The Ceramics and Specialties business group includes products for the ceramic industry and high-performance graphite through its subsidiary Timcal.

www.wbb.co.uk

Leading international producer of plastic clays for ceramics (also known as ball clays).

Advanced

www.kyocera.com

Manufactures and markets advanced ceramic products for industrial and automotive applications, as well as the Ceratip line of ceramic, cermet and carbide-cutting tools for industrial metal removal.

www.advceramics.com

World's largest producer of boron nitride powders, shapes, and coatings as well as other specialty ceramics.

www.sgceramics.com

St Gobain ceramics

www.gequartz.com

Leading developers and manufacturers of fused quartz materials/ products for the semi-conductor, fibre optic and lighting industries.

www.acccos.com

Ceramic Cosmetic Powders, part of the Advanced Ceramics Company.

www.olmec.co.uk

Olmec Advanced Materials supply carbon and graphite materials and ceramic and metallic powders as well as manufacturing components.

www.advancedceramicmaterials.com

Ceramic Substrates and Components Ltd supply technical, precision and industrial ceramics. Their Advanced Materials Division deals with materials such as macor, alumina, silicon nitride, shapal and zirconia.

www.tech-ceramics.co.uk

HP Technical Ceramics supply various ceramic components of standard formulations as well as engineered specials.

Surface

www.ive.org.uk

The Institute of Vitreous Enamellers (IVE) aims to advance enamelling technology, science and best practice.

www.emcoatings.com

EM Coatings innovate in the field of engineered coating development and application.

www.colours.matthey.com

Johnson Matthey's Colours Nad Coatings Division is one of the world's largest integrated suppliers of colour and its associated coating materials to a wide range of industries.

www.capper-rataud.co.uk

Colours for ceramics.

www.ferro.co.uk

Global producer of performance materials for manufacturers.

www.sneydoxides.co.uk

Sneyd Oxides Limited manufacturs high quality stains, glazes and inks.

Production

www.the-hothouse.com

Computer-aided design facilities for shape and pattern development.

www.hankook.com/english/intro/2.html

Producers of fine dinnerware, bone china and super-strong china.

www.topchoice.com.hk

Hong Kong tableware company famous for its fine design and quality.

www.noritake.com

Manufacturer of a range of ceramic-based products across different industries, including advanced ceramics and tableware.

www.porcel-sa.com

Portuguese ceramic manufacturer.

www.inhesion.com.hk

Hong Kong-based tableware producer.

www.churchillchina.plc.uk

Supplier of wide range of ceramic tableware and related products to the hospitality and home markets around the world.

www.steelite.com

Manufacturer of ceramic tableware for the hospitality industry.

www.tenmat.com

Manufacturer of specialised, high-performance, non-metallic composite engineering materials and components.

www.ceramtec.de

CeramTec Group set standards in high-performance ceramics.

www.cevp.co.uk

CEVP Ltd supplies and machines all the widely available refractory, ceramic and graphite materials used in the vacuum industry.

www.ceram.co.uk

Ceram is an international organisation working for clients involved in ceramics and materials processing, the manufacture of ceramic components, or the use of ceramic products.

www.bioceramics.com

Morgan Matroc Bioceramics, a subsidiary of the Morgan Crucible Company Plc, designs, manufactures and markets ceramic implant devices for orthopaedic, reconstructive and surgical applications.

154

004–005 Many thanks to Karim Rashid 014–015 Body armour with thanks and acknowledgement to Morgan Ceramics, photography by Xavier Young 016 Boron nitride photography by Xavier Young 017 Ceramic watch with thanks and acknowledgement to Rado 018–019 Thanks and acknowledgement to Kyocera 021 Ceramic spring with thanks and acknowledgement to Ceram Technology, photography by Xavier Young 022 Glass-bonded mica with thanks and acknowledgement to Mykroy Mycalex, photography by Xavier Young 023 Glass ceramic photography by Xavier Young 024–025 Tennis racket with thanks and acknowledgement to Head UK 026–027 Graphite guitar with thanks and acknowledgement to CEVP 028 Silicone nitride with thanks and acknowledgement to St Gobain Advanced Ceramics, photography by Xavier Young 029 Hip replacement with thanks and acknowledgement to Morgan Ceramics, photography by Xavier Young 030–031 Silicone carbide, photography by Xavier Young 032–033 Transparent concrete with thanks and acknowledgement to Bill Price 036 Dental brackets with thanks and acknowledgement to 3M 037 Cordierite ceramic with thanks and acknowledgement to Corning 038–039 Britefuture with thanks and acknowledgement to Britefuture 040–041 Humpty Dumpty with thanks and acknowledgement to Dominic Jones and Chris Lefteri 042–043 Ceramic Speakers with thanks and acknowledgement to Nacsound 044–045 Feelings cup, photography by Xavier Young 046–047 Caneware mixing bowl with thanks and acknowledgement to Mason Cash, photography by Xavier Young 048–049 Spark plug photography by Xavier Young 050–051 Winter Mug with thanks and acknowledgement to Pepe Garcia Zaragoza, photography by Xavier Young 052–053 Thanks and acknowledgement to Sorma 054–055 Thanks and acknowledgement to Hering-Berlin 056–057 With thanks and acknowledgement to KC Lo 060–061 Porcelain with thanks and acknowledgement to Droog Design 062–063 Photography by Xavier Young 064 Siesta with thanks and acknowledgement to Héctor Serrano 065 Vallauris Flower Bricks with thanks and acknowledgement to Gallery Kreo 066–067 Strata-casting with thanks and acknowledgement to Kathryn Hearn, photography by Andrew Watson 068–069 Loop Chair with thanks and acknowledgement to Twenty Twenty-One 070–071 Thanks and acknowledgement to Hella Jongerius 072–073 Pestle and Morter with thanks and acknowledgement to Wade Ceramics 074–075 Polar Molar with thanks and acknowledgement to KC Lo 075–076 Stones with thanks and acknowledgement to Knoll UK 078–079 Concrete composites with thanks and acknowledgement to Victoria Rothschild and Anna Usborne 080–081 Ciment Fondu with thanks and acknowledgement to Kelvin J. Birk 082–084 Kalpa Vase with thanks and acknowledgement to Satyendra Pakhalé, photography by Corné Bastiaansen 086–087 Dry-powder compaction with thanks and acknowledgement to Advanced Ceramic Substrates 088–089 Dental Crowns with thanks and acknowledgement to Scottlander 090 Thanks and acknowledgement to Wade Ceramics 091 Toilets and sinks with thanks and acknowledgement to Ideal Standard 092–094 Jiggering and jollying photography by Xavier Young 094–095 Throwing with thanks and acknowledgement to Satyendra Pakhalé, photography by Corné Bastiaansen 096 Injection moulding with thanks and acknowledgement to Ceram Technology, photography by Xavier Young 097 Rapid protoyping with thanks and acknowledgement to Royal Doulton 098 Thanks and acknowledgement to Laser Cutting UK 099 Rolling pin with thanks and acknowledgement to Wade Ceramics, photography by Xavier Young 100–101 Thanks and acknowledgement to Ceram Technology, photography by Xavier Young 104–105 Thanks and acknowledgement to HG Matthews, photography by Xavier Young 106–107 Thanks and acknowledgement to Selee Corporation 108–109 Ceramic paper with thanks and acknowledgement to 3M, photography by Xavier Young 110–111 Ceramic fibres with thanks and acknowledgement to 3M, photography by Xavier Young 112–113 With thanks and acknowledgement to Aquafil, photography by Xavier Young 114–115 Ceramic microspheres with thanks and acknowledgement to 3M, photography by Xavier Young 116 Ceramic magnets with thanks and acknowledgement to Magnet Applications, photography by Xavier Young 117 Machinable glass ceramic with thanks and acknowledgement to Precision Ceramics, photography by Xavier Young 118–119 Semi-finished advanced materials with thanks and acknowledgement to Advanced Ceramics, photography by Xavier Young 120–121 Quartz surfacing materials with thanks and acknowledgement to Dupont Zodiaq, photography by Xavier Young 122–123 Fireslate with thanks and acknowledgement to Fireslate, photography by Xavier Young 124–125 Porcelain tiles with thanks and acknowledgement to Apavisa Porcalanico, photography by Xavier Young 128–129 Photography by Xavier Young 130–131 Thanks and acknowledgement to UK General Hybrid, photography by Xavier Young 132–133 Grid to Blob series with thanks and acknowledgement to Karim Rashid 134–135 Thanks and acknowledgement to Syndecrete 136–137 Thanks and acknowledgement to Rob Kesseler 138–139 Thanks and acknowledgement to Liquid Ceramic 142–143 Thanks and acknowledgement to Royal Doulton

Thanks to Central Saint Martins for their kind support. Kathryn Hearn and Rob Kesseler at Central Saint Martins for their support and suggestions for the many features in this book. Thanks to the various people in the companies I have included, who are too numerous to mention but have spent time describing the various aspects of their materials and production methods and supplying images. A massive thank you to Richard Williams and Richard Delaney at Royal Doulton, who took the time out to introduce me to the various aspects of manufacturing with ceramics. To David Gordard at Wade Ceramics for his tour of the factory. To Dr John Liddle at Ceram Research for the many phone calls and valuable samples.

To all the people at RotoVision, who I don't know but are instrumental in bringing these books together. In particular, to my new editor Leonie Taylor, who continues the RotoVision tradition of allowing me to work with some the best people I could ever hope for. To Amanda Bown, for helping with the images, to Luke Herriott, who has been invaluable in bringing this whole series together. Once again to Xavier Young for his inspirational photographs. Thanks again to Zara Emerson, a consistent partner throughout this series. To Karim Rashid for his generous words and support with this and other books and for writing the foreward for Ceramics.

Finally, to my beautiful wife Alison for her ideas, support and total encouragement.

Thank you

Index